OXFORD
AT WORK

STANLEY C. JENKINS

ACKNOWLEDGEMENTS

Thanks are due to Graham Kew and Diana Lydiard for help with the supply of some of the photographs used in this publication. Other images were obtained from the Lens of Sutton Collection, the Witney & District Museum, and the rest are from the author's own collection.

First published 2018

Amberley Publishing
The Hill, Stroud
Gloucestershire, GL5 4EP

www.amberley-books.com

Copyright © Stanley C .Jenkins, 2018

The right of Stanley C. Jenkins to be identified as the Author of this work has been asserted in accordance with the Copyrights, Designs and Patents Act 1988.

ISBN 978 1 4456 8045 3 (print)
ISBN 978 1 4456 8046 0 (ebook)

British Library Cataloguing in Publication Data. A catalogue record for this book is available from the British Library.

Origination by Amberley Publishing.
Printed in the UK.

CONTENTS

INTRODUCTION

The city of Oxford is attractively situated on a level plain in the midst of verdant meadows, thickly planted with trees, and bounded on three sides by the Thames (known hereabouts as 'the Isis') and its slow-running tributary, the River Cherwell. The early history of Oxford echoes that of countless other English country towns in that it originated as a minor Celtic or Saxon village, and was subsequently elevated to the status of an Anglo-Saxon county town. A minster church was founded at a relatively early date, while Oxford found a new role during the Viking wars, when it became the site of a fortified 'burh' or stronghold on the borders of Wessex and the Danelaw.

Like many other provincial towns, Oxford flourished during the medieval period, by which time it was starting to emerge as a trading and commercial centre with an embryonic cloth-making industry. However, the local textile trade never really took off – one problem being foreign competition from the Netherlands. Oxford nevertheless found a new source of employment and prosperity when it became the seat of a world-famous university, which exerted and continues to exert a dominant influence on the local economy.

Large-scale manufacturing industries were not established in Oxford until the twentieth century, when two huge car factories were established at nearby Cowley, while in more recent years the city and university have flourished as a major tourist attraction, as well as a world-class centre of learning and research.

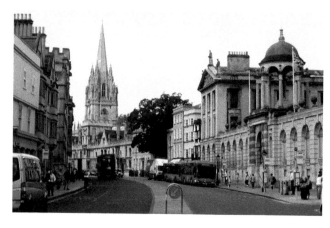

A classic view of Oxford's gently curving High Street – generally known as 'The High' – looking west towards the crossroads at Carfax.

ORIGINS & EARLY GROWTH

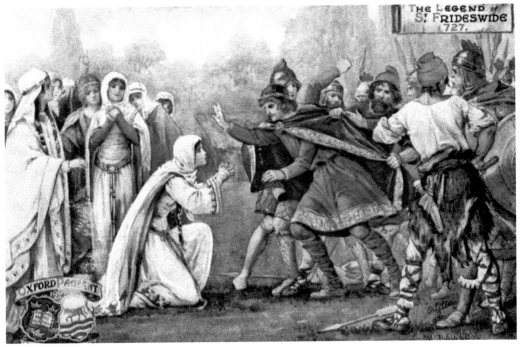

A somewhat fanciful view of a confrontation between Frideswide and Algar, her would-be suitor, as depicted in a colourful postcard dating from 1907.

THE LEGEND OF ST FRIDESWIDE

The early history of Oxford is shrouded in mystery, although the city has a picturesque 'founding legend', based upon the story of Frideswide, the patron saint of the city and university. Frideswide was an eighth-century nun of noble birth, who rejected the amorous advances of Algar, the Earl of Leicester. Having fled into a deep forest, she prayed to God for help, and the earl was, in consequence, struck blind when he tried to pursue her. Frideswide

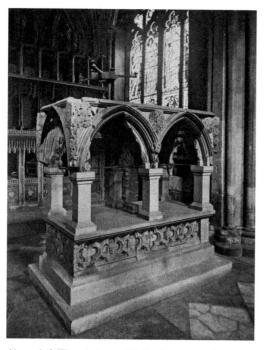 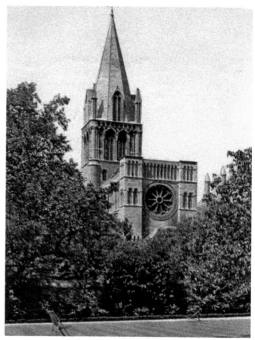

Above left: The shrine of St Frideswide, which dates from around 1289.

Above right: The exterior of Christ Church Cathedral, photographed from the Meadows c. 1955.

was thereby able to return to Oxford, where she lived in peace for the rest of her days, having established a nunnery and a minster church.

Frideswide died in or around 727, and was buried in St Mary's Church, but her remains were later reinterred in the priory church, and her much-restored shrine, dating from around 1289, can be seen between the Lady Chapel and the north choir aisle; its carved stonework depicts a wealth of luxuriant foliage, a reminder, perhaps, of the saint's flight into the forest. The story of Frideswide is known only from sources which post-date the refoundation of her house as an Augustinian priory in the early twelfth century – some 400 years after the death of the saint.

AETHELFLAED & THE ORIGINS OF THE CITY

Oxford is first mentioned by name in the early tenth century, the town being one of the fortified 'burhs' or strongholds that King Alfred and his descendants had constructed to protect Wessex during the Viking Wars. At that time, Alfred's son Edward the Elder and his daughter Aethelflaed were slowly but inexorably recovering English territory from the Danes. Aethelflaed was the widow of a Mercian nobleman who had been entrusted with the defence of London, and it is likely that she would have employed her father's engineers to lay out the new burh at Oxford. Although there was already a minster church and a small pre-existing settlement in the vicinity, the new town was on an immeasurably greater scale, and for that reason Lady Aethelflaed can be seen as the founder of Oxford as an urban centre.

The burh at the Oxen-ford was built in a strategic position at a crossing point on the River Thames. It was well sited for defensive purposes, and was laid out between the Thames and its many subsidiary channels and the River Cherwell. The surrounding marshes and low-lying areas provided natural defensive features, and the burh itself was encircled by stockaded banks and stone-faced ramparts. To the west, a 'hythe' or wharf was constructed on the River Thames, and this enabled the new settlement to be supplied by water transport from Reading and London. Despite a destructive Danish attack in 1002, this West Saxon stronghold soon developed into a prosperous and thriving town.

OXFORD AT THE TIME OF THE DOMESDAY BOOK

The Domesday Book records that, in 1086, Oxford contained 'as well within the wall as without … 243 houses which pay geld, and besides these there are 500 houses less 22 so waste and destroyed that they cannot pay geld'. Additionally, there were 217 houses held by the king, bishops or other important people, together with a further eighty dwellings held by the priests of St Michael's or St Frideswide's. From this documentary evidence, it appears that late Saxon Oxford may have contained as many as 900 houses, and assuming an average figure of four or five people per household, this would suggest a population of approximately 3,800–4,000 people.

The Domesday Book reveals that there were at least six corn mills in the Oxford area, including two in Oxford, two in Headington and two in nearby Cowley. One of the Oxford mills was worth 10s, although the other was not valued (suggesting that it may not have been in operation); the Headington mills were worth £2 10s; while the Cowley mills were valued at £2 and £1 15s. These mills would have been water powered – windmills were unknown in Anglo-Saxon England. Archaeological finds, in the form of items such as spindle whorls, loom weights and crucibles, hint at a range of urban trades including spinning, weaving, leather working and metalworking, the implication being that late Saxon Oxford was already a prosperous and expanding community.

The streets of the Saxon burh were laid out in a cruciform arrangement within the protective wall, and this basic town plan has survived until the present day. The crossroads at the centre of the medieval town became known as 'Carfax', or The Four Ways (*quatre voies*), these four thoroughfares being Cornmarket, St Aldates, High Street and Queen Street, which extend north, south, east and west respectively towards the long-demolished city gates.

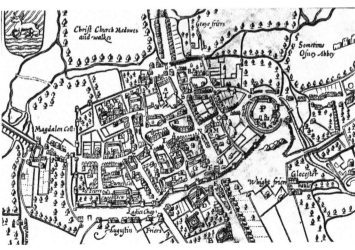

This Tudor map of Oxford is orientated from east to west, Magdalen Bridge being visible on the extreme left, while the city wall is clearly depicted. Carfax is marked by a letter 'N'.

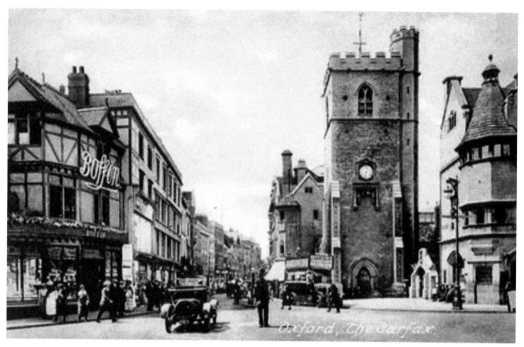

This old postcard view shows Carfax Tower at the junction of Queen Street, St Aldates, Cornmarket and High Street. This embattled tower is the only remaining portion of St Martin's Church, which was demolished in 1896. The font and other monuments were moved to nearby All Saints. Carfax is generally regarded as the very centre of Oxford.

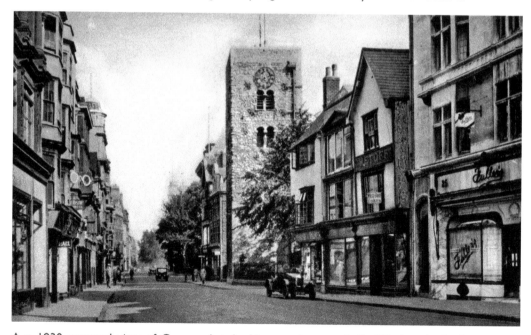

A *c.* 1930 postcard view of Cornmarket, looking north towards St Giles', with the Saxon tower of St Michael-at-the-Northgate Church visible in the centre of the picture.

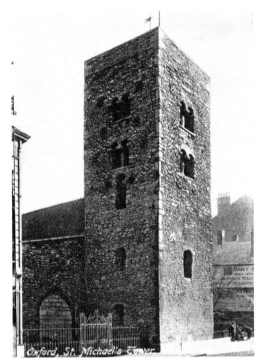

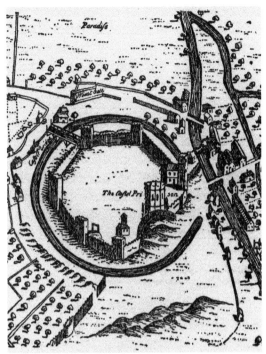

Above left: St-Michael-at-the-Northgate Church, at the north end of Cornmarket, is of particular interest insofar as its five-storey Anglo-Saxon tower is thought to have served as a defensive tower beside the north gate of the Saxon burh and, as such, it is the oldest building in Oxford. This *c.* 1910 view shows the tower from Cornmarket, and provides a detailed study of the north and west sides of this historic structure. A blocked doorway on the second floor must have given access to the wall walk at the top of the city wall.

Above right: The pioneer map-maker Ralph Agas depicted Oxford Castle as a roughly circular fortress with six mural towers.

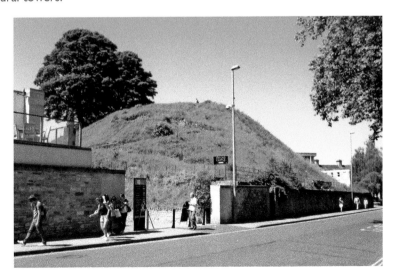

The grass-covered 'motte', or Castle Mound, remains a prominent local landmark.

OXFORD CASTLE & ST GEORGES'S TOWER

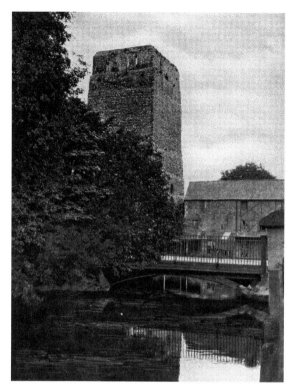

Left: A glimpse of St George's Tower during the early twentieth century. Castle Mill can be seen to the right.

Below: A view showing the west side of the tower in 2012.

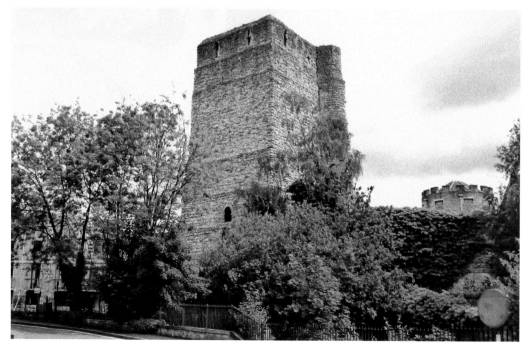

Oxford Castle was founded shortly after the Norman Conquest by Robert d'Oyly, who erected a motte-and-bailey castle with timber buildings, which were later replaced by permanent stone-built structures, including a tall keep on top of the Castle Mound. Most of the castle was dismantled after the Civil War, but a prison and county court were built on the site during the 1840s. A map surveyed by the pioneer map-maker Ralph Agas (c.1540–1621) suggests that Oxford Castle was a roughly circular fortress with six mural towers and a keep on top of the Castle Mound.

Five of the castle's six mural towers have been destroyed, but St George's Tower remains extant. It is thought that this grim-looking tower may have been erected during the tenth century to serve as a rudimentary keep, because the earth of the newly raised motte was unable to bear the immense weight of a stone building. Although clearly of military origin, the tower also functioned as the bell tower of the long-demolished castle chapel.

EARLY GROWTH BEYOND THE CITY WALL

The Domesday Book suggests that Oxford's very first 'suburbs' appeared beyond the wall by the tenth or eleventh centuries. The most important of these early suburbs was St Clements, which was situated just outside the East Gate, and had originated as a 'brycggestt' or 'bridge settlement' on the east side of the River Cherwell. Archaeological investigation indicates that there may have been similar Anglo-Saxon suburbs beyond the North and West gates (the area in front of the North Gate known as St Giles had certainly appeared by the twelfth century).

Urban expansion took place steadily throughout the medieval period, and in 1334 Oxford was the eighth most important provincial town in England, based upon its tax quota of 1,828 shillings. In 1377 the tax-paying population had reached 2,357, although Oxford had slipped to fourteenth in the ranking of provincial towns. By the time of the 1662 hearth tax the city was, once again, the eighth most important provincial town in England. The 1662 hearth tax lists 4,205 taxable hearths excluding the colleges, which would imply a total population of around 20,000 (on the assumption that each household contained around five occupants).

Oxfordshire was heavily involved with the Civil War, which began on 22 August 1642. The first large battle took place at Edge Hill, near Banbury, on 23 October, and although this engagement was inconclusive, it enabled the king to set up his wartime capital in Oxford. The city was extensively fortified by a sophisticated system of earthwork bastions, while at the same time the Royalists created a number of detached outposts at places such as Woodstock Palace and Bletchingdon House. For the next four years Oxford was in a state of semi-siege, though the Parliamentarians made no attempt to storm the city, and on 24 June 1646 the Royalists surrendered without bloodshed. The Civil War defences were dismantled at the cessation of hostilities, but the extended perimeter may have had a residual effect upon the process of urban expansion, insofar as it confirmed that suburbs such as St Giles were now regarded as an integral part of the inner city.

EARLY SUBURBS AT ST CLEMENT'S & ST GILES'

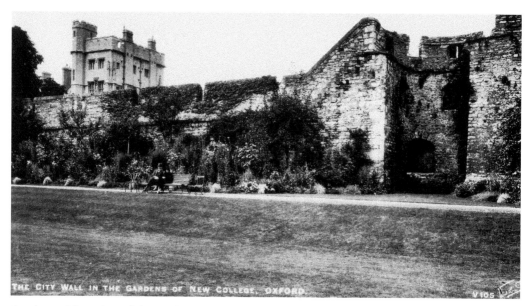

A substantial section of the medieval city wall can be seen in New College gardens, and five open-backed bastions remain in situ. These medieval defences were obsolete by the time of the Civil War; hence the need to construct complex earthwork defences that formed an outer rim or perimeter that extended well beyond the confines of the medieval city.

A view of 'The Plain' at St Clement's in 2013. This open space on the east side of Magdalen Bridge was formerly the site of St Clement's Church, which was demolished in 1829/30 after the construction of a new church in nearby Marston Road. Dedications to St Clement are associated with areas of Scandinavian settlement, and this implies that St Clement's may have originated as a small colony of Danish traders and merchants on what was then the outer edge of Oxford.

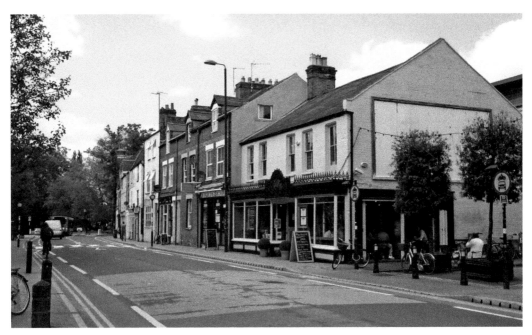

St Clements Street is one of three busy thoroughfares that radiate from The Plain. The other two are Cowley Road and Iffley Road. This 2013 view is looking west towards Magdalen Bridge.

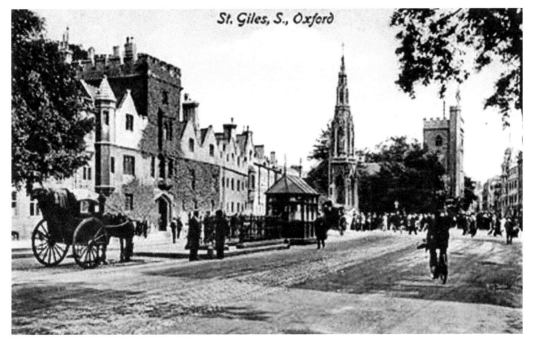

Situated immediately to the north of the medieval city wall, St Giles' was one of Oxford's first suburbs. This c. 1910 view, from an Edwardian colour-tinted postcard, is looking south towards the city centre, Balliol College being visible to the left. This college was founded around 1263 by John de Balliol (c. 1200–68) of Barnard Castle, the father of King John of Scotland.

St John's College, on the east side of St Giles', traces its history back to 1437, when Archbishop Chichele founded St Bernard's College as a college for Cistercian monks. The college was dissolved during the Reformation, but in 1555 it was refounded by Sir Thomas White (c. 1550–1624), a prosperous London merchant. St John's has four quadrangles, the façade of Front Quad being the former St Bernard's College, while North Quad was added during the 1880s. The college's recent alumni include former Prime Minister Tony Blair.

ORIGINS OF COWLEY & HEADINGTON

Although now regarded as an integral part of Oxford, Cowley originally comprised the villages of Temple Cowley and Church Cowley. The Church of St James, in Church Cowley, was rebuilt by the diocesan architect G. E. Street (1824–81) during the 1860s. The most significant modification carried out in that time was the addition of a much-enlarged nave, which now dwarfs the rather stubby west tower.

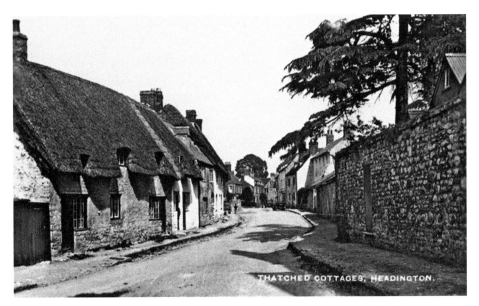

Like Cowley, Headington was once a rural village, but according to F. G. Brabant's 1933 *Little Guide to Oxfordshire* the enlarged village had, by that time, become 'quite overshadowed by the large new suburb of Oxford, which includes, besides Headington, Highfield and Headington Quarry'. Mention of Headington Quarry serves as a reminder that Headington was the source of much of the stone used in the construction of the Oxford colleges. This Edwardian postcard view shows Old Headington village during the early 1900s. The traditional stone cottages seen on the left were demolished in the 1930s.

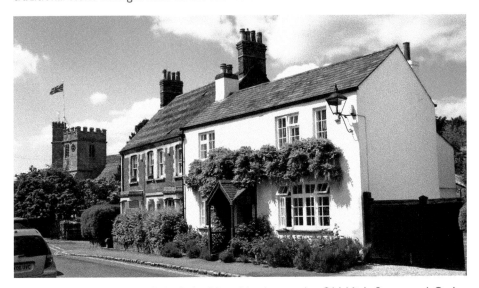

Old Headington, which is linked the New Headington by Old High Street and Ostler Road, retains at least some of the atmosphere of a rural village in spite of suburban encroachment during the nineteenth and twentieth centuries. The parish church, dedicated to St Andrew, incorporates a nave, aisles, chancel, south porch and an embattled west tower.

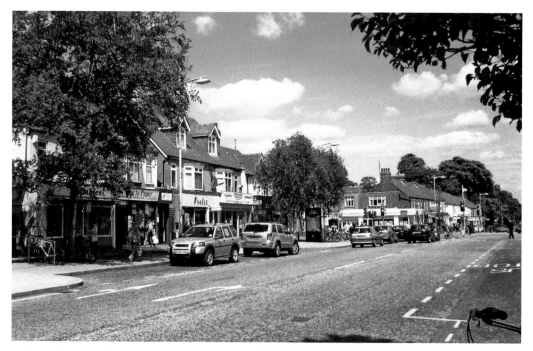

A general view of London Road, Headington, looking eastwards in 2012. The rise of the motorcar industry resulted in an expansion of Oxford. The main period of growth took place during the early twentieth century when the city expanded in all directions, absorbing once rural communities such as Headington and Cowley.

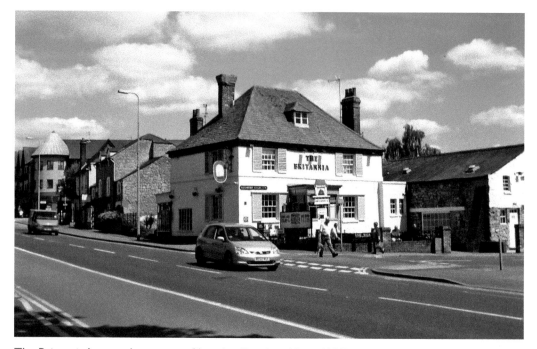

The Britannia Inn, on the corner of London Road and Lime Walk, was once a rural inn.

THE RISE OF THE UNIVERSITY

Oxford received a charter from Henry II in 1155, and this confirmed that the city enjoyed the same customs, rights and liberties as London. As usual in the medieval period, trade within the town was regulated by a merchant guild. The cloth-making trade appeared to be flourishing, but as mentioned earlier, Oxford never developed as a clothing town, and whereas there had been around sixty weavers within the town during the reign of King John, there were none a century later.

Oxford became a recognised centre of learning during the twelfth century. It is not entirely clear why Oxford emerged as a major seat of learning, although one theory suggests that the rise of the University of Oxford stemmed from the quarrel between Henry II and Thomas Beckett, which prompted the king to order the English clerks who were studying in Paris to return home 'as they valued their benefices'. The influx of scholars from Paris provided impetus for the growth of a *stadium generale,* or University at Oxford, which was already a centre of learning. It should perhaps be mentioned that the word *universitas* was applied to any guild or corporation, and medieval scholars were regarded as apprentices who, after seven years of study, became masters and were thereby qualified to teach.

Relations between the university and the townsfolk were not always entirely amicable, and indeed murderous fights between 'town' and 'gown' erupted from time to time, culminating in the 'Great Slaughter', which broke out on St Scholastica's Day, 10 July 1355, and lasted for two days, resulting in the deaths of sixty-two scholars and perhaps thirty townsfolk.

As the number of students increased, hostels or 'halls' were opened to accommodate them, while benefactors began to found autonomous colleges, which tended to be much larger than the halls and were supported by generous endowments. It is estimated that there were, in the mid-fifteenth century, around seventy halls in Oxford, together with ten colleges, though in the fullness of time, further colleges were founded (many of the earlier halls were absorbed or converted into the new collegiate foundations). By 1852 there were nineteen colleges and five halls (including Magdalen Hall, which became Hertford College in 1874, and St Edmund's Hall, which was incorporated as a college in 1957).

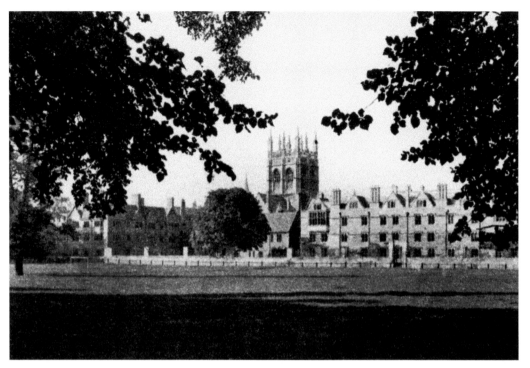

Merton College is the oldest Oxford college, having been founded in 1264 by Walter de Merton (c. 1205–77), Lord Chancellor and Bishop of Rochester. It is situated in Merton Street, which runs parallel to the High Street. Christ Church Meadows and Merton Field are immediately to the south.

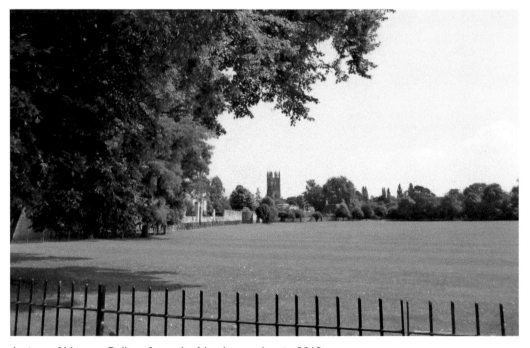

A view of Merton College from the Meadows, taken in 2012.

NEW COLLEGE – THE PROTOTYPE OXFORD COLLEGE?

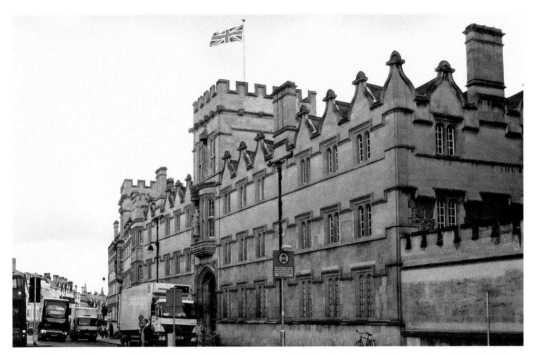

Despite its name, New College is in fact a very old institution, which was founded by William of Wykeham (*c.* 1324–1404), Bishop of Winchester, in 1379. The 'Great Quad' was complete by 1386, while the cloister and bell tower were added in 1400. In architectural terms, New College can be seen as the prototype for all later Oxford colleges insofar as it was built to a regular plan comprising a quadrangle, with gate tower, hall, chapel and library – this more or less standardised layout was similar to that of contemporary monastic foundations. Like other early colleges, New College features a range of monastic-style cloisters. New College has now expanded well beyond the confines of its original site, and the college now includes nineteenth- and twentieth-century buildings, in addition to its medieval core.

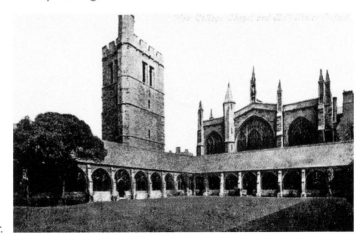

A *c.* 1920s postcard of New College showing the monastic-style cloisters, the college chapel and the bell tower.

NEW COLLEGE AND MAGDALEN COLLEGE

 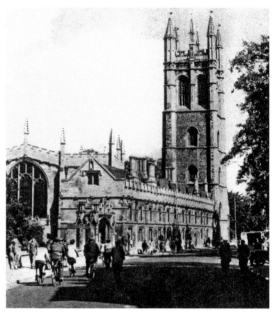

Above left: The medieval gate tower of New College, as depicted in a postcard view of New College Lane dating from around 1920. The archway that can be seen to the right is a public right-of-way that connects New College Lane to Queen Street.

Above right: The main street frontage of Magdalen College seen from the High Street around 1950. The large building that can be seen on the extreme left is the college chapel, which forms part of the south range of the cloisters. The impressive tower has a height of 144 feet.

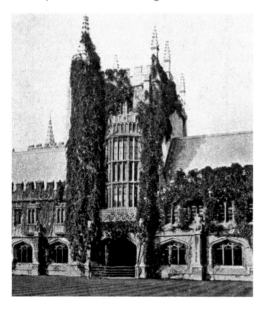

The Founder's Tower, on the west side of the cloister, had been the gate tower of the original college buildings, but it now forms a link between the cloister and the adjacent St John's Quad.

WILLIAM ORCHARD & HIS WORK AT MAGDALEN COLLEGE

It is often said that we do not know the names of the medieval masons who designed the great churches and monasteries, although in reality several of these individuals are known to history; one thinks, for example, of Richard of Stow, who constructed the great tower of Lincoln Cathedral, or Richard of Farleigh, who built the 404-foot tower and spire of Salisbury Cathedral. Similarly, in the case of Oxford, the work of William Orchard (*ob.* 1504) at Magdalen College is also comparatively well known. It is interesting to note that Orchard was also a contractor and quarry owner, with interests in the famous quarries at Headington, from which he supplied stone for use in new works in Oxford and at Eton College.

It should perhaps be pointed out that the word 'mason' is often loosely applied to any tradesman involved with stonework, whereas there were many kinds of stone workers including hewers, dressers, setters and labourers. The construction of a large and complex medieval building such as Magdalen College would also have required considerable numbers of lime burners, plumbers, smiths, glaziers and wrights, the latter being needed to erect the floors, roof timbers and other wooden components. These varied tradesmen would have been directed and managed by a master mason such as William Orchard, who (in today's terms) combined the functions of architect, building contractor and project manager.

Magdalen College was founded in 1485 by William Patten of Waynflete in Lincolnshire (*c.*1400–86), Bishop of Winchester – the dedication being a reflection of the bishop's devotion to St Mary Magdalen, who, according to the Bible, discovered that Christ had risen from the sepulchre. Construction commenced in 1467 and the main buildings including the cloister and the famous tower were completed by around 1509.

The High Street frontage incorporates part of the Hospital of St John the Baptist, which predated the college and had occupied part of the site. The College Chapel formed part of the south range of the cloister, while the Founder's Tower, which is on the west side of the cloister, had been the gate tower of the original college buildings, andnow forms a link between the cloister and the adjacent St John's Quad.

The main High Street gateway is a Victorian structure erected in 1885 and replete with decoration, including statues of William of Waynflete, St Swithun and St Mary Magdalen. William of Waynflete, in a niche to the left of the doorway, is holding a model of his college, while Mary Magdalen, to the right of the doorway, is holding her emblematic jar of ointment. The buildings at the rear of the gateway, known as St Swithun's Buildings, were added during the 1880s, and the architects were George Bodley (1827–1907) and Thomas Garner (1839–1906).

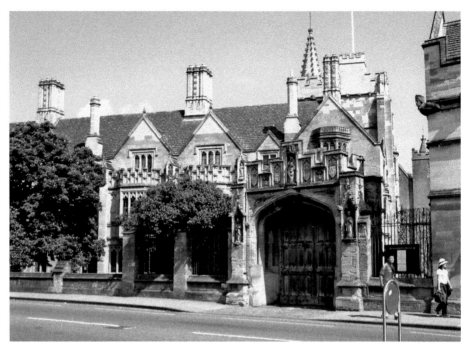

A detailed view of the main gateway, which is a Victorian structure dating from 1885. The figure of St Mary Magdalen is situated in a niche immediately to the right of the gate.

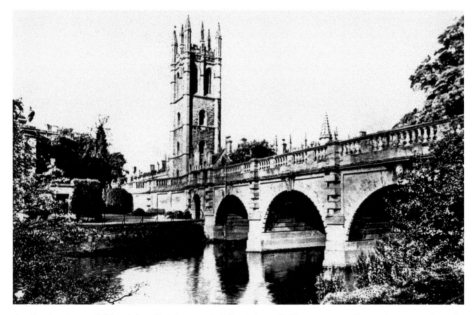

A classic view of Magdalen Bridge, with Magdalen College tower featuring prominently in the background. The present Magdalen Bridge was built in 1772–78, although further work was carried out in the 1790s. The bridge, which has eleven arched spans of varying dimensions, was widened in 1882 to provide sufficient room for the Oxford & District Tramway Co.'s 4-foot-gauge tramline.

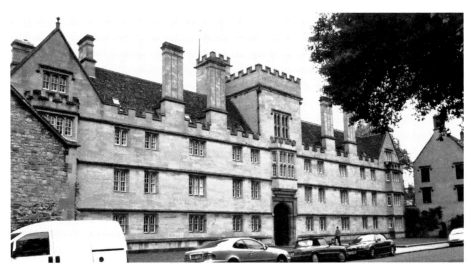

Wadham College was founded by Nicholas Wadham (1532–1609) and his wife Dorothy (1534/5–1618), who, as his executor, obtained a royal letter patent in 1610 and undertook all of the work that was required to bring the scheme to completion by 1613, when the new college was opened. Although she was widowed at the age of seventy-five, Dorothy lived long enough to see the college flourish before her death in 1618. The Wadhams are buried in the north transept of Ilminster church, in their native Somerset.

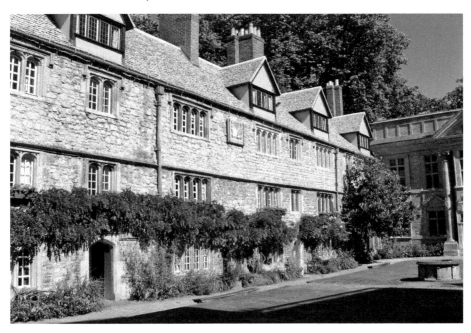

St Edmund's Hall originated in the mid-thirteenth century as a hall of residence for undergraduates, but in 1957 it was granted a charter of incorporation by Elizabeth II and thereby became a conventional college. In contrast to neighbouring Queen's College, the buildings are small in scale, and have an intimate domestic quality, as shown in the accompanying view of the North Quadrangle.

CHRIST CHURCH COLLEGE & CATHEDRAL

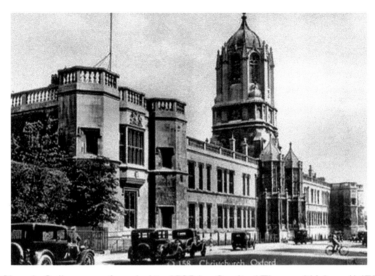

Christ Church College was founded in 1525 by Cardinal Thomas Wolsey (1470–1530), who intended to build a magnificent new college on land that had formerly belonged to St Frideswide's Priory. Several monasteries were suppressed to provide funds for the new college, which was to have an establishment of 180 persons including a dean, 100 canons and thirteen chaplains, together with professors, teachers and choristers. In the event, Cardinal Wolsey's grandiose building scheme was brought to an abrupt halt in 1529 when he fell from power; around three-quarters of the great quadrangle had been built by that time, together with the largest hall and kitchen in Oxford. This colour-tinted postcard shows the college from St Aldates.

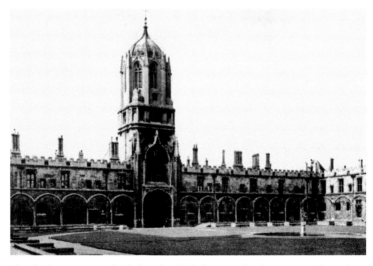

Tom Quad, which measures 264 feet by 261 feet, is the largest quadrangle in Oxford, although it has a curiously unfinished appearance insofar as the cloisters were never roofed over and finished as Cardinal Wolsey had intended.

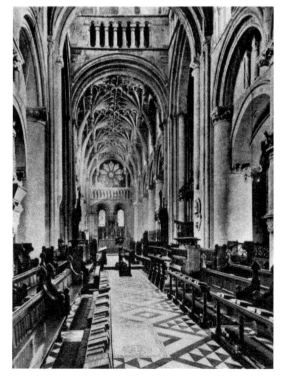

Tom Tower, at the entrance to the college, is something of a hybrid. The gatehouse was built by Cardinal Wolsey whereas the iconic tower, with its ogee cap, was added by Sir Christopher Wren (1632–1723). Within the tower is 'Great Tom', a 6.25-ton bell that once hung in Osney Abbey.

Cardinal Wolsey had intended to demolish St Frideswide's Priory Church and replace it with a new college chapel on the north side of Tom Quad. According to the seventeenth-century antiquary Anthony Wood (1632–95), the cardinal pulled down the west end of the nave, 'containing almost half the body of the church, intending that the remaining part should serve only for private prayers'. At the time of the Dissolution of the Monasteries Henry VIII created six new sees, one of these being the diocese of Oxford, and in 1546 the truncated Church of St Frideswide became Oxford Cathedral. Members of the various religious orders were 'pensioned off' at time of the Reformation, though many former monks found new work as bishops or parish priests. Former monks received pensions of around £5 or £6 per annum, which was roughly equivalent to the wage of an unskilled workman.

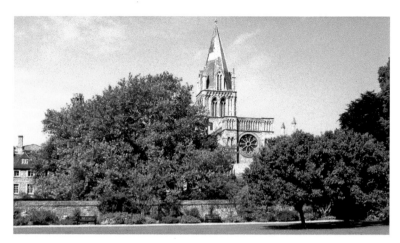

Christ Church Cathedral, which also serves as Christ Church College Chapel, forms an integral part of the collegiate buildings, and it is in consequence difficult to obtain external photographs of this Anglo-Norman structure. The lower part of the tower dates from the Norman period, but the upper part, with its corner pinnacles and octagonal Early English spire, was added during the thirteenth century. The prominent rose window was inserted by the Victorian architect Sir George Gilbert Scott (1811–78), who carried out a major restoration in 1870–76.

THE BODLEIAN LIBRARY

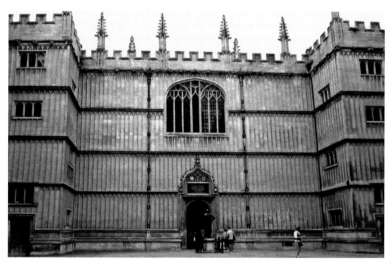

The university library was originally housed in St Mary's Church, but in the fifteenth century Duke Humphrey of Gloucester (1391–1447) donated his magnificent library to the university. Sadly, the collection was dispersed during the reign of Edward VI, although the library was restored by Sir Thomas Bodley (1545–1613) and reopened, with 2,000 books, in 1602. The 'Old Bodleian' occupies a group of historic buildings including the 'Schools Quadrangle', Convocation House, the Divinity School, and an entrance hall known as the Proscholium.

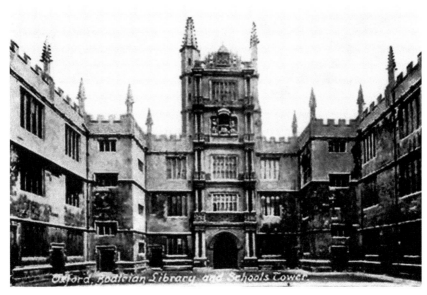

The eastern side of the Schools Quadrangle, showing the the Tower of Five Orders, which directly faces the Proscholium. As its name implies, this early seventeenth-century structure is adorned with paired columns exhibiting the five main classical orders: Tuscan, Doric, Ionic, Corinthian and Composite.

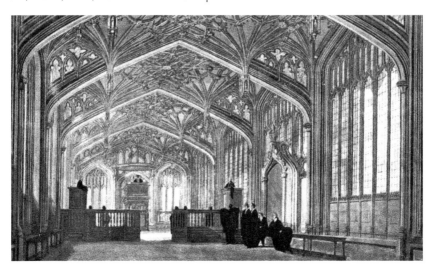

An Edwardian postcard view of the Divinity School, which is situated below Duke Humphrey's Library and entered via the Proscholium. The Divinity School was built in at least two stages over a period of years, much of the work having been accomplished in the 1420s, although the magnificent vaulted ceiling was added around sixty years later after the decision had been taken to increase the height of the building to two storeys so that the library could be accommodated on the upper floor. The remarkable vaulting, which has often been described as a 'fan vault' (although it would be more accurate to describe it as a 'lierne vault'), is thought to have been designed by William Orchard, whose initials 'WO' appear on several of the vault bosses.

THE CLARENDON BUILDING & THE OXFORD UNIVERSITY PRESS

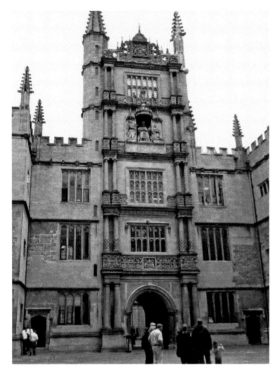

Left: A detailed view showing the impressive Tower of Five Orders.

Below: Designed by Nicholas Hawksmoor, this impressive structure was paid for by the profits of Clarendon's *History of the Great Rebellion,* which had been written by Edward Hyde, 1st Earl of Clarendon (1609–74) and published posthumously in 1702–04 – the royalties having been given to the university. The Clarendon Building was completed in 1715 and it was, until 1830, the home of the Clarendon Press, on which the university's books and the authorised bibles and prayer books were printed. The building, which is now used as offices by the Bodleian Library, features porticoes on its north and south façades, while the female figures that adorn the top of the building represent the nine muses – the present statues are fibreglass replicas.

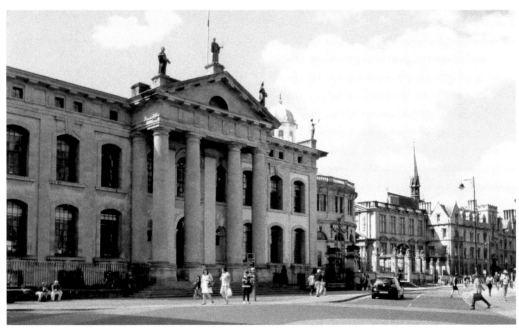

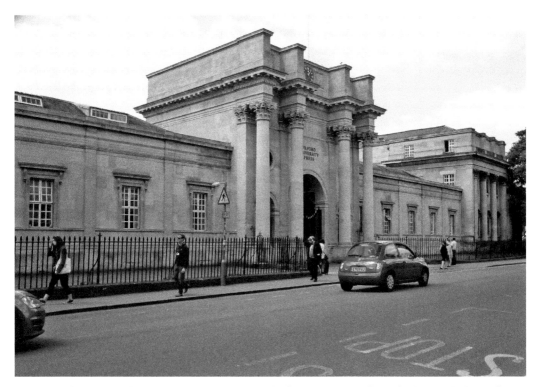

The Clarendon Press was moved to a new Oxford University Press building in Walton Street in 1830. The new structure is a handsome classical building with a central block and two wings, the central block having a monumental entranceway with four giant Corinthian columns. The front and south wing was begun in 1826 and finished in 1828 to the designs of the American-born architect Daniel Robertson (1770–1849), while the north wing and west ranges were completed by 1830 under the direction of Edward Blore (1787–1879). The original building stands upon a Headington stone plinth with Bath stone facing and dressings.

With over 6,000 employees, the Oxford University Press is one of the largest academic publishers in the world. The OUP remains a department of the university which is governed by a group of fifteen academics appointed by the vice-chancellor and known as the 'Delegates of the Press'. They are headed by the secretary to the delegates, who serves as OUP's chief executive.

CANAL & RIVER TRANSPORT

Rivers were the freight arteries of pre-industrial England. The Thames had been navigable for centuries, and in medieval times the river was extensively used for the transport of stone, timber and other large and heavy consignments. It is known, for example, that a wharf had been established on the upper Thames at Eynsham, some 5 miles to the west, by the year 1312, when a 'hythe' is mentioned in a lease of Eynsham Abbey.

In an age in which decent roads simply did not exist, intrepid boatmen and barge masters managed to prod, pole or bow haul their cumbersome wooden vessels along many miles of barely navigable waterway. In summer or in times of drought, barges might lie aground for several weeks, while in winter the untamed rivers became raging torrents, defying all attempts to move vessels upstream against the current. Oxford had, more or less from its inception, been an inland 'port' on the River Thames and, as such, it was in contact with other towns and cities such as Wallingford, Reading and London.

Canals were merely extensions of natural waterways and, as the pace of industrialisation gathered momentum towards the end of the eighteenth century, large numbers of these new man-made 'navigations' were constructed. Some of these, such as the Leeds & Liverpool Canal, were seen as coast-to-coast links, while others – particularly those in the English Midlands – were essentially links between existing waterways, opening up vital lines of internal communication. By 1800 there were approximately 3,000 miles of navigable waterway in England, roughly one-third of which had been built between 1760 and the end of the century. Ambitious internal voyages became possible, and with coastal transport hampered by the impressment of merchant seamen for service in the Royal Navy, goods could be sent, for example, from London to Birmingham or from Bristol to Hull via inland waterways.

Oxford was linked to the Midlands by the Oxford Canal and to the River Severn via the Thames & Severn Canal. The Oxford Canal was incorporated by Act of Parliament in 1769, the engineers being James Brindley (1716–72) and his son-in-law Samuel Simcock. Construction was a protracted business, although the waterway was opened between Hawkesbury Junction and Banbury by 1778. The canal was opened as far south as Wolvercote in 1789, and completed through to Oxford in January 1790.

Although rapidly eclipsed by the railways, working narrowboats used the Oxford Canal until comparatively recent years, and in the Second World War a new concrete canal wharf was opened at Kidlington so that supplies for Kidlington aerodrome could be brought in by water transport. In the late 1940s and early 1950s the flush-decked canal 'tankers' *Tweed* (motor) and *Rea* (butty) were among the last trading boats on the southern Oxford Canal. Owned by Thomas Clayton Ltd of Oldbury, they were crewed by Mr and Mrs Albert Beechey, and carried gas tar from Oxford gasworks to distilleries in the Midlands. Another Clayton's pair, at work around 1950, were the *Umea* (motor) and *Orwell* (butty), which were two 'gas boats' later replaced the *Tweed* and *Rea* on the Oxford run. Mr Beechey retired around 1962 and the *Umea* and *Orwell* were then crewed by Mr and Mrs George Page until, sadly, Mrs Page was drowned in Warwick locks.

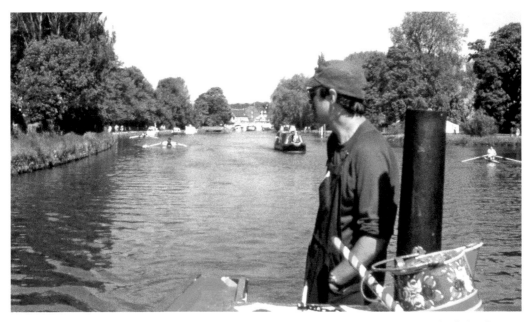

The River Thames below Folly Bridge, photographed from the cabin roof of the former Thomas Clayton narrowboat *Towy* in June 1985. This busy waterway is used by a variety of craft, although there is no longer any commercial traffic.

This animated scene shows the same section of the river south of Folly Bridge around 1912. The ornate wooden craft that line the east bank were luxuriously furnished and elaborately decorated college barges that functioned as floating boathouses and clubrooms.

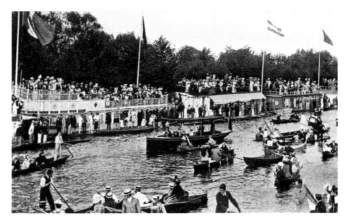

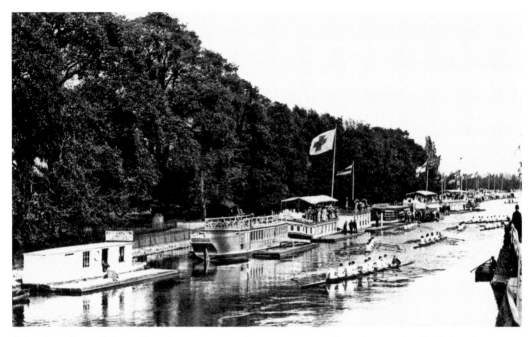

A further view of the college barges moored stem to stern along the east bank of the river. Many of these distinctive craft had been built locally by Messrs Salter Brothers of Folly Bridge.

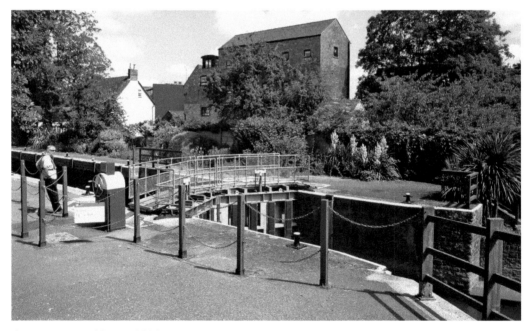

Osney Lock on 22 June 2018. The large red-brick building that can be seen in the background is Osney Mill, a former flour mill that was built in 1845 on a much earlier site. The mill was, at various times, used as a saw mill and a 'bone mill' in which animal bones were ground down to make fertiliser. The building was gutted by fire in 1946 and, having remained derelict for over sixty years, it has latterly been adapted for residential use.

Although it is now part of Oxford, the Thameside village of Iffley has retained a delightful rural character. Iffley Lock dates from around 1630 and, as such, it was one of the first pound locks on the River Thames. The present-day lock was built in 1924.

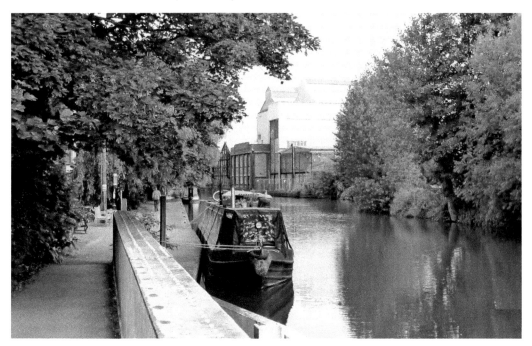

A further glimpse of the river, looking northwards along the towpath towards Jericho. The large building that can be seen in the distance was the Oxford Electric Lighting Station, which was opened in 1892 and closed in 1969.

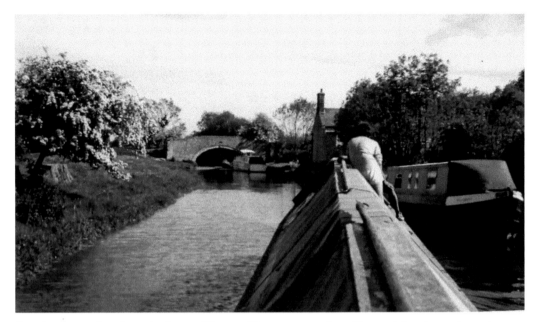

Another view taken from the former Thomas Clayton narrowboat *Towy* as it heads southwards on the Oxford Canal near Kidlington. Clayton's boats were traditionally named after rivers. Like other canal boats, they were normally crewed by a husband-and-wife team, who shared the tiny cabin with their children.

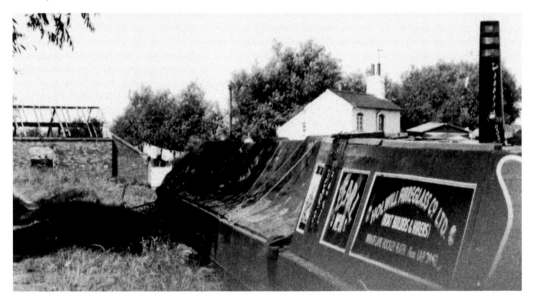

A glimpse of the narrowboat *Pearl* moored on the Oxford Canal at Wolvercote Junction around 1967. It is believed that *Pearl* was built at Braunston as an unpowered 'butty' for Thomas Claytons Ltd in 1935, and rebuilt as a motor boat in 1945. In the early 1960s boatman Charlie Atkins and his family were working the *Pearl* on the Oxford Canal in conjunction with the butty *Umea*. When trading, these former Claytons' boats would have been fitted with flush decks, rather than sheeted holds.

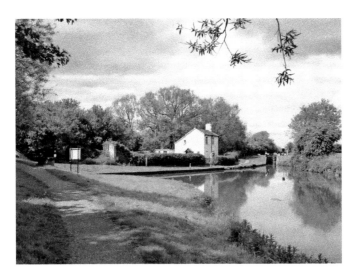

Wolvercote, a small village around 2½ miles to the north of Carfax and now joined to the city by ribbon development, is both a canal junction and a railway junction. Here, the former Oxford, Worcester & Wolverhampton line diverges north-westwards from the Birmingham main line, while the Oxford Canal is linked to the nearby River Thames by a short waterway known as the Duke's Cut. Opened in 1789, Duke's Cut was a valuable link for narrowboats passing from the canal system to the Upper Thames, while in later years it became the main southern exit point for pleasure craft leaving the Oxford Canal.

The nearby Wolvercote Paper Mill formerly supplied paper to the Oxford University Press. A steam engine was installed in 1811 and, thereafter, narrowboats were employed to bring coal from the Midlands via the Oxford Canal and Duke's Cut Sadly, the paper mill was closed in 1998 and the buildings were then demolished. The local authority has recently approved a scheme for the construction of 190 houses on this 'brown field' site, together with a GP surgery, offices and a community centre.

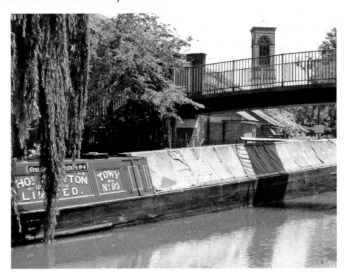

The narrowboat *Towy* on the Oxford Canal at Jericho on 9 July 2015.

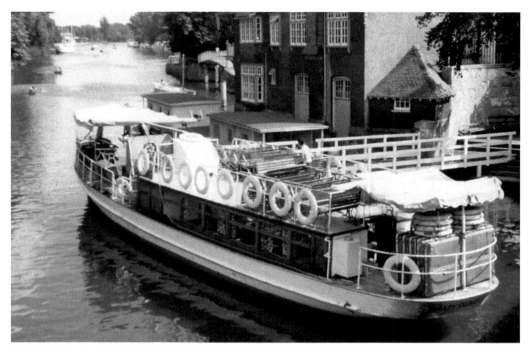

The motor vessel *Mary Stuart* alongside Salter Brothers' jetty in 1974. It is interesting to note that the *Mary Stuart* was originally a Dutch vessel known as the *Kagerplas*. Although colloquially known as a 'steamer', the *Mary Stuart* is diesel powered. With a length of 60 feet she can accommodate 162 passengers. Salter's steamers normally had a crew of around half a dozen, comprising a skipper, engineer and purser, together with waitresses and deck hands.

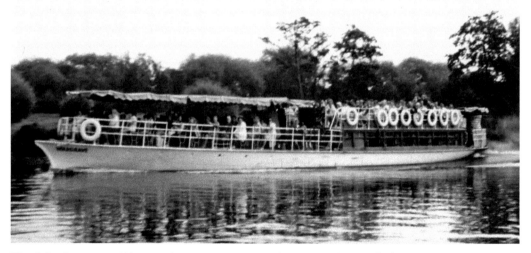

The Salter's steamer *Wargrave* forges upstream on the approaches to Oxford in the summer of 1974. The *Wargrave* was built by Salter's in 1913, and she has an overall length of 84½ feet and can accommodate 199 passengers. The *Wargrave* is a typical Salter's vessel, in that she incorporates an enclosed saloon, with an open upper deck and a lengthy open foredeck. The steering wheel is sited immediately in front of the saloon.

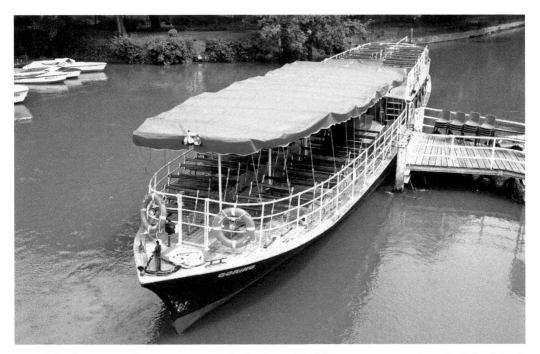

Salter's steamer *Goring* is seen at Folly Bridge in 2012. This veteran vessel was built by Salter's in 1913; she is 85 feet overall and can accommodate 199 passengers. All of these former steam-powered vessels are now listed on the National Register of Historic Vessels.

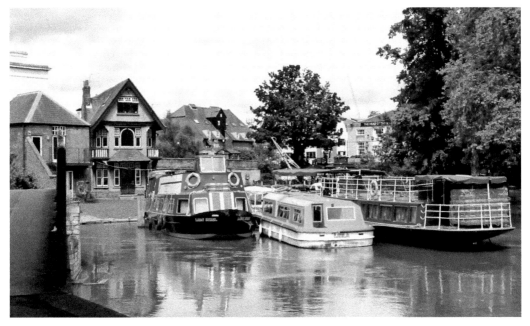

A further view of Salter's jetty at Folly Bridge in 2012, showing the *Mary Stuart* tied up alongside the *Lady Ethel* and the *Leila*. The ornate structure that can be seen to the rear of the *Lady Ethel* was built by Salter's in 1900 to provide offices and waiting room facilities.

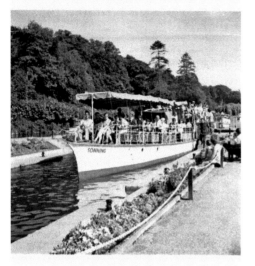

**RIVER THAMES
PASSENGER SERVICES
1974**

SALTER BROS. LTD.
FOLLY BRIDGE
OXFORD

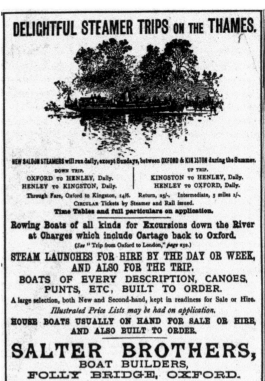

DELIGHTFUL STEAMER TRIPS on the THAMES.

NEW SALOON STEAMERS will run daily, except Sundays, between OXFORD & KINGSTON during the Summer.

DOWN TRIP.	UP TRIP.
OXFORD TO HENLEY, Daily.	KINGSTON TO HENLEY, Daily.
HENLEY TO KINGSTON, Daily.	HENLEY TO OXFORD, Daily.

Through Fare, Oxford to Kingston, 14/6. Return, 25/-. Intermediate, 5 miles 1/-.
CIRCULAR Tickets by Steamer and Rail issued.
Time Tables and full particulars on application.

**Rowing Boats of all kinds for Excursions down the River
at Charges which include Cartage back to Oxford.**
(See " Trip from Oxford to London," page 252.)

**STEAM LAUNCHES FOR HIRE BY THE DAY OR WEEK,
AND ALSO FOR THE TRIP.**

**BOATS OF EVERY DESCRIPTION, CANOES,
PUNTS, ETC, BUILT TO ORDER.**
A large selection, both New and Second-hand, kept in readiness for Sale or Hire.
Illustrated Price Lists may be had on application.

**HOUSE BOATS USUALLY ON HAND FOR SALE OR HIRE,
AND ALSO BUILT TO ORDER.**

SALTER BROTHERS,
BOAT BUILDERS,
FOLLY BRIDGE, OXFORD.

Above left: This picture shows the *Sonning*, as depicted on the cover page of the 1974 Salter's timetable. The *Sonning* was built by Salter Brothers in 1902, and converted to diesel operation in 1947. She was sold in 1982 and is now working on the River Trent.

Above right: A Victorian handbill advertising Salter's Thames steamer service.

The Oxford Canal terminus was purchased by Lord Nuffield in 1937, and Nuffield College was built on the site in 1949–60. This modern college boasts an impressive tower that rises 150 feet to the top of the spire.

SALTER BROTHERS STEAMERS & BOATYARD

Salter Brothers, the famous Oxford boatbuilding firm, was founded by John (1826–90) and Stephen (1834–1937) Salter in 1858. Salter's commenced their Thames steamer service in 1888, the first steamer being the *Alaska*, which had been built in 1883 by Messrs Horsham & Co. of Bourne End. The service ran from Oxford to Kingston, and the 91½-mile journey was accomplished in two days, with an overnight stop at Henley-on-Thames. Passengers were able to embark and disembark at locks or other recognised stopping places, and light refreshments were served aboard the steamers – although as the Salters were a Wesleyan Methodist family, alcohol was not available.

The picture below, dating from around 1955, shows the steamer *Henley,* which was built for Salter Brothers by Edwin Clarke & Co. of Brimscombe in 1896. She was sold in 1976 and now works in the London area between Westminster, Kew and Hampton Court.

In addition to providing a Thames steamer service, Salter's activities included boat building, which was carried out in their boatyard at Folly Bridge. By the end of the nineteenth century Salter's were building over 300 boats per year. The firm employed around fifty people throughout the year, although the labour force was doubled during the summer months when extra staff were taken on to work the steamers.

The company constructed a diverse range of vessels including punts, canoes, skiffs, cCollege barges and even lifeboats. In 1866, for example, the university lifeboat *Isis* was ceremonially launched on the Thames in front of a huge crowd; according to a contemporary newspaper report, 'the whole of the college barges were packed with spectators as well as the banks of the river for a considerable distance'. The lifeboat, which had been paid for by a local fundraising campaign, was put through its paces by a crew of university oarsmen, after which the new lifeboat was taken through the streets to the railway station, from where the GWR conveyed it free of charge to Hayle in Cornwall, where it immediately entered active service.

In 1923 Salter's built the ill-fated *Marchioness* for Joseph Mears of Richmond. This typical Thames steamer, some 85 feet long overall, was commandeered for service during the Dunkirk evacuation and, as such, could claim to have been one of 'the Little Ships of Dunkirk'. However, most of the requisitioned Thames steamers were left at Sheerness throughout the period of the evacuation, as they had no condensers and were, in consequence, unable to run on sea water. Sadly, this historic vessel was run down by the dredger *Bowbelle* in London in the early hours of 20 August 1989, resulting in the loss of fifty-one lives.

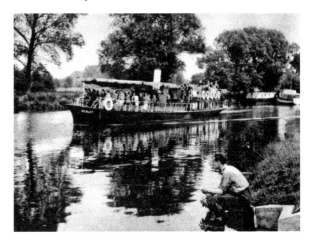

The steamer *Henley,* which was built for Salter Brothers by Edwin Clarke & Co. of Brimscombe in 1896.

OXFORD'S RAILWAYS

Railways are of particular significance as far as Oxford is concerned because they were, for many years, the only source of large-scale industrial employment in the area. The first railway to impinge upon the Oxford district was the Great Western Railway, which was completed throughout its length from London to Bristol by 1841. The GWR directors were soon planning extensions to the north and west of the original main line, one of these new lines being a branch from Didcot to Oxford, which was opened on 12 June 1844. Meanwhile, other GWR-backed lines were being planned and, in the following year, bills were sent up to parliament seeking consent for two northwards extensions from the Oxford line, one of which would run north-westwards towards Worcester and Wolverhampton, while the other would extend boldly northwards along the Cherwell Valley in the direction of Rugby.

The Oxford, Worcester & Wolverhampton Railway was advicated for by Black Country coal owners and industrialists, who hoped to build a main line from Oxford, through Moreton-in-Marsh and Worcester, to Wolverhampton. The OW&WR was initially seen as a member of the Great Western 'family' and, with Isambard Kingdom Brunel (1805–59) as its engineer, this new main line through the Cotswolds was planned as an important broad gauge route.

The Oxford, Worcester & Wolverhampton Railway Bill was presented to parliament in the early months of 1845, together with a related bill for a northwards extension of the broad gauge from Oxford to Rugby. Both lines would diverge from the existing GWR railhead at Oxford, the Oxford, Worcester & Wolverhampton line heading north-west to Worcester via the Evenlode Valley, while the Oxford & Rugby Railway would strike due north along the Cherwell Valley towards Banbury.

The two Great Western bills passed through parliament at a time when there was immense concern over the evils of the 'break of gauge', and certain radical politicians were known to favour state intervention to ensure eventual uniformity of gauge. The bills were, as a result, subjected to unprecedented scrutiny, but in spite of bitter opposition from the London & Birmingham Railway, the Midland Railway and individual politicians such as Richard Cobden, the Oxford & Rugby and the Oxford, Worcester & Wolverhampton bills both received the royal assent on 4 August 1845.

The Oxford, Worcester & Wolverhampton Railway Act provided consent for the construction of a railway from the Oxford branch of the GWR, through Evesham and Worcester, to the Grand Junction Railway station at Wolverhampton, with branches to the River Severn at Diglis Basin, to the Birmingham & Gloucester Railway at Stoke Prior, from Amblecote to Stourbridge, and from Brettel Lane to Kingswinford. The Oxford & Rugby line was opened from Oxford to Banbury on 2 September 1850, while, after many vicissitudes, the Oxford, Worcester &

Wolverhampton main line was completed throughout between Wolvercote Junction and Evesham on 4 June 1853.

In 1847, two nebulous schemes – the Buckinghamshire & Brackley and the Oxford & Bletchley railways – were combined to produce the Buckinghamshire Railway, a more tangible project that was empowered to build a 31¼-mile link from the L&NWR main line at Bletchley to Oxford, with a branch to Banbury. The L&NWR was a substantial shareholder, and had provided £450,000 to finance this two-pronged attack on the GWR.

The Buckinghamshire Railway had originally intended to reach Oxford by running over the rival Great Western Railway, but when the GWR refused to allow access over its own route the Buckinghamshire company was obliged to build an independent line running parallel to the GWR as far as Rewley Road. Here, a small wooden terminus was opened on 20 May 1851. The completion of the line was celebrated in the usual way, with glowing speeches and a great banquet. Meanwhile, the L&NWR had agreed to take out a 999-year lease, promising the Buckinghamshire company's shareholders a guaranteed dividend of 4.5 per cent of all surplus profits. However, the Buckinghamshire Board continued to meet, and its reports to the shareholders provide glimpses of the new railway in operation. In August 1851 it was revealed that, between 5 May and 3 August, over 7,072 passengers had been conveyed to London to visit the Great Exhibition 4,428 of which had booked from Oxford.

This was not, by any means, the end of railway development in and around Oxford, and in the next few years lines were opened to Abingdon (1856), Witney (1861), Princes Risborough (1864) and Woodstock (1890).

A PROPOSED RAILWAY WORKS AT OXFORD

In 1860 the Oxford, Worcester & Wolverhampton Railway was merged with the Newport, Abergavenny & Hereford Railway and other companies in order to form the West Midland Railway, while in 1863 the WMR was itself amalgamated with the Great Western Railway. As a corollary of these complex developments Richard Potter, the chairman of the enlarged GWR Board, embarked upon a scheme to construct a large carriage works at Oxford at a cost of around £90,000. The result was immediate hostility from the university, and there was significant opposition within the railway company, particularly from Daniel Gooch (the future GWR chairman), who felt that the money would have been 'entirely wasted as the place was unsuitable and the cost far exceeded anything required'. Faced with bitter opposition from all sides, the supporters of the carriage works decided not to proceed with their highly controversial plans.

Despite the failure of the carriage works scheme, the GWR remained a major source of employment, and by the 1930s over 560 people were employed in the various departments. In 1929–30, for example, Oxford station had a labour force of 199 under a 'special grade' stationmaster, while 226 worked in the Locomotive Department, ninety-four worked in the Engineering Department and a further fifty-two were employed in the Carriage and Wagon Department. When the staff at neighbouring stations such as Littlemore and Morris Cowley are taken into account, the total number of people employed by the GWR in the Oxford area would have been around 600.

Those employed at the station and engine sheds included sixty-six drivers, sixty-six firemen, twenty signalmen, twenty-seven shunters, twenty-nine porters, nine ticket collectors, seven passenger booking clerks and twenty-six motor delivery drivers, together with a range of other employees such as goods clerks, goods porters, carriage cleaners, signal lampmen and waiting room attendants.

THE GREAT WESTERN RAILWAY AT OXFORD

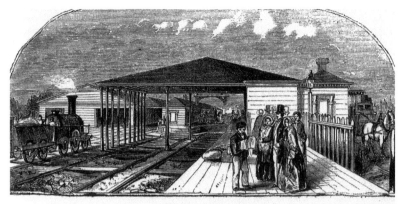

OXFORD STATION.

Opened on 12 June 1844, the original GWR station at St Aldates was a terminus with wooden buildings and an overall roof. When the line was extended northwards to Banbury trains had to reverse into and out of the station, a situation which pertained until 1 October 1852, when the Oxford to Birmingham line was completed throughout. The station at Grandpont remained in use as a goods depot until November 1872, when it was finally abandoned.

Oxford's second station was opened on 1 October 1852. It was of wooden construction, with a barn-like overall roof that spanned its two platform roads and two additional up and down through lines. A terminal bay was located at the north end of the down platform, and there was a two-road carriage shed on the down side. Station buildings were provided on both sides, timber-framed construction having been necessary because, allegedly, the station had been built on wooden stilts on a raised embankment.

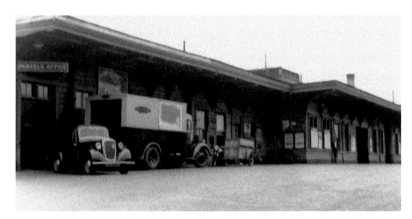

A view of the up side station buildings during the British Railways era, around 1955. Oxford station had, throughout its life, been a source of controversy, in that its somewhat ramshackle buildings were thought to be inappropriate for a cultural centre and major tourist destination such as Oxford. The station was rebuilt in 1971, but the 'cheap and nasty' facilities provided continued to attract heated criticism, and the station was finally rebuilt on a more substantial and satisfactory scale in 1990.

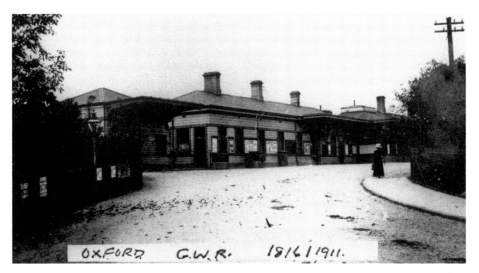

The main station building, on the up side, boasted a range of accommodation including a booking office, waiting rooms, refreshment room, parcels office, stationmaster's office, mess rooms and toilets. The up and down platforms were linked by an underline subway, and lengthy canopies were provided on both sides. This old postcard view shows the up side station buildings on 18 June 1911.

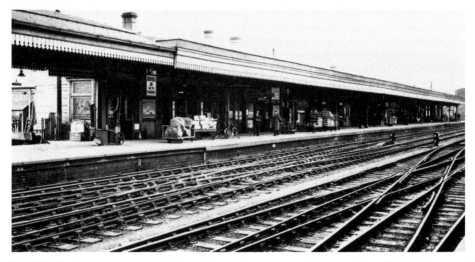

In 1910 the layout was extended and, having lost its wooden overall roof, Oxford gained lengthened up and down platforms. The station featured a quadruple-track layout, which provided four lines between the platforms, the two outer lines being the up and down platform lines, while the inner lines were used by freight trains or other workings that were not required to stop at the station. An unusual feature of the revised track layout were the two intermediate crossovers at the centre of the station, which linked the centre through lines to the up and down platform lines and thereby allowed two trains to be accommodated in each platform at the same time. The two main platforms were long enough to deal with fourteen-coach express trains. Platform one, the main up platform, had a length of 918 feet, while platform two, on the down side, was 916 feet in length.

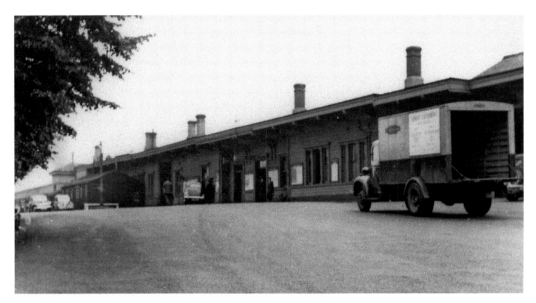

The down side buildings were very similar to their counterparts on the up platform, as shown in this c. 1955 view.

A later view of the down side station buildings taken in 1971. Facilities on the down platform included waiting rooms and staff accommodation, together with a separate down side booking office.

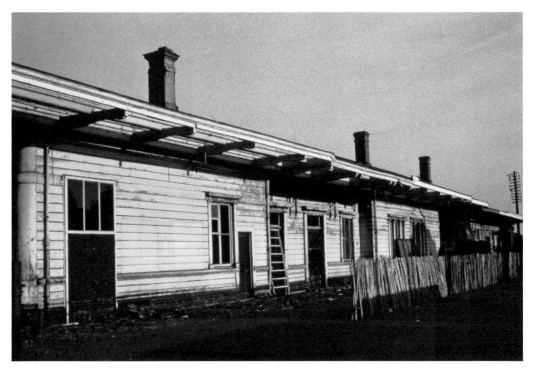

A detailed view of the down side station buildings in 1970. Preliminary demolition work had already started, and these timber-framed Victorian buildings would soon be swept away as part of a major reconstruction scheme.

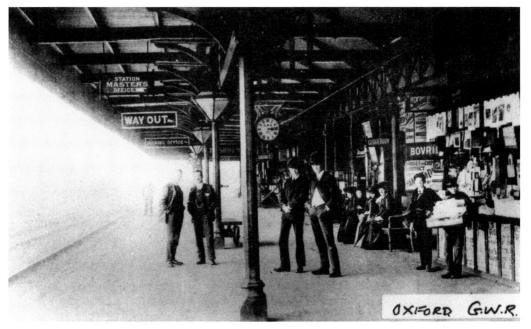

A postcard view showing the up platform during the early years of the twentieth century.

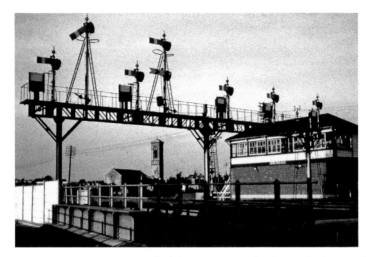

The immediate station area was signalled from two signal cabins, which were known as Oxford station north box and Oxford station south box. The north box was sited at the north end of the platforms on the up side while, as its name implied, the south box was situated at the opposite end of the station on the down side. Both of these cabins were typical early twentieth-century Great Western designs, with low-pitched hipped roofs and characteristic five-pane 'high visibility windows, which were supposed to give the signalmen an unimpeded view of the surrounding area. The accompanying photograph shows the north box in 1970, the distinctive tower of St Barnabus Church being visible in the background.

Oxford station north box was a very busy box with ninety-seven levers, which was normally manned by two signalmen, a booking boy and a traffic regulator. Until 1942, this cabin had been known as 'Oxford Engine Shed Box'. The south box, which contained a fifty-seven-lever frame, had been known as 'Oxford Goods Shed Box' until 1942. These two cabins controlled Oxford's quadruple track layout together with the scissors crossovers, and the complex track work and signalling at each end of the station. In the Second World War, the ground floors of these two vital boxes were encased in protective brickwork as an air raid precaution measure.

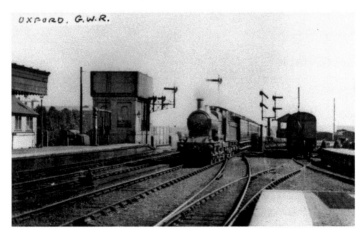

A re-boiled 'Achilles' class 4-2-2 single-wheeler hurries through Oxford station with a northbound express around 1912.

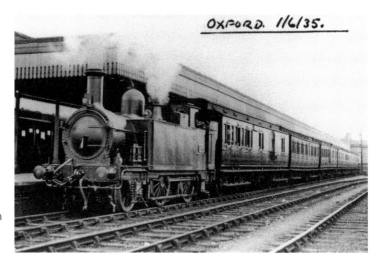

A 'Metro' class 2-4-0 tank locomotive stands in the down-side bay platform with a Witney branch train on 1 June 1935.

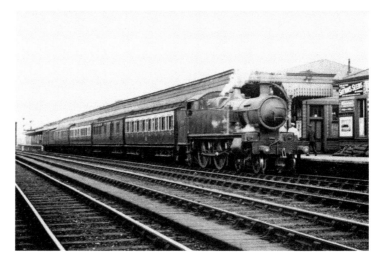

A 'County Tank' 4-4-2T locomotive is seen at Oxford with a main line stopping train, probably around 1925.

The present Oxford station has relatively spacious modern facilities, as shown in this recent view of the up-side buildings. The quadruple track layout has been retained, but the up and down sides of the station are now liked by a fully enclosed footbridge, which has replaced the earlier subway.

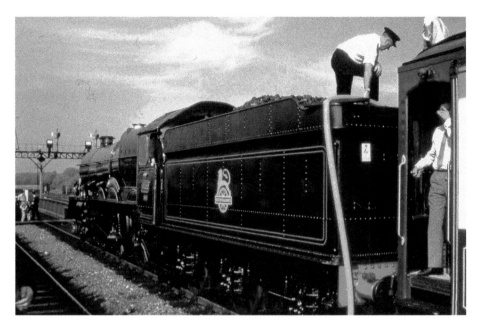

'King' class 4-6-0 locomotive No. 6000 *King George V* stands on the down through line with the Bulmers cider train on 2 October 1971. Steam locomotives had been banned from the main line system in 1968, but the appearance of the cider train heralded a welcome revival of steam operation. As British Rail had removed the water columns from Oxford station, the local fire brigade had to be called in to replenish the locomotive's 4,000-gallon tender with the aid of a fire hose.

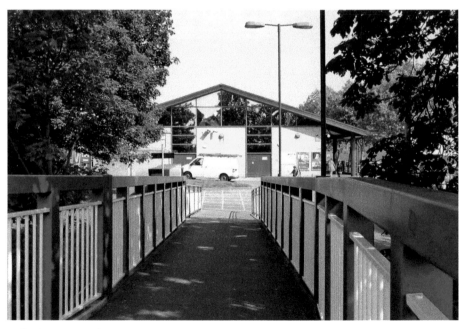

A further view of the modernised station, seen from the pedestrian footbridge, which provides a useful 'shortcut' across the Botley Road.

REWLEY ROAD L&NWR STATION

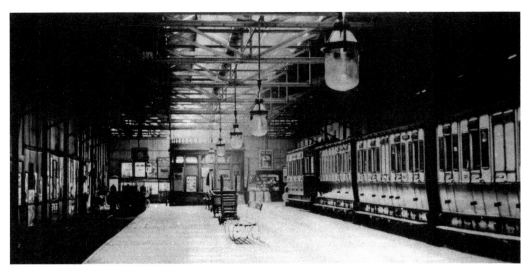

The interior of the train shed at Oxford Rewley Road station c. 1912. The passenger facilities at Rewley Road consisted of a double-faced island platform with terminal roads on either side and a wooden station building fronting the concourse. The platform was partially covered by an overall roof, which was designed by Sir Charles Fox (1810–74) utilising prefabricated components identical to those used by Messrs Fox & Henderson during the construction of the Crystal Palace.

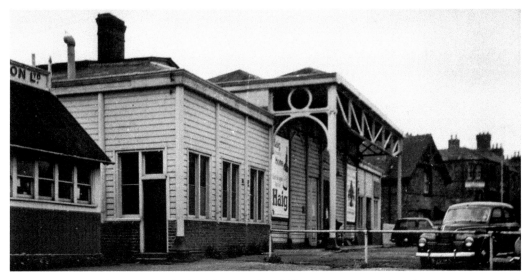

The station frontage at Oxford Rewley Road. This station was closed to passengers with effect from 1 October 1951, when Bletchley services were diverted into the adjacent Western Region station. The former L&NWR station (which became part of the London Midland & Scottish Railway in 1923) remained in use for goods traffic for many years, although its site is now occupied by the Said Business School and modern housing developments.

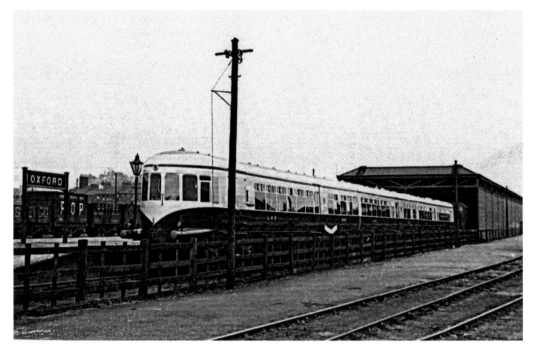

In 1938, the LMS introduced an experimental three-car articulated diesel unit, which was able to cover the 77 miles between Oxford and Cambridge in just 1¾ hours. Although the trials were regarded as a success, further development was halted by the outbreak of the Second World War in September 1939.

OXFORD GASWORKS

The Oxford Gas Light & Coke Co. was incorporated by an Act of Parliament on 23 May 1818, and a small gasworks was then built on the north bank of the Thames on a 2-acre site in the Friars district of St Ebbe's. Gas streetlighting was introduced in Oxford in 1819, while in 1852 the gasworks was said to be 'very substantial and convenient'. the managing director at that time was Charles James Sadler and the engineer was Thomas Atkins. The gas company was reformed and expanded in 1869 in order to include St Giles's, Cowley, Iffley, Headington, North Hinksey, South Hinksey and Botley. Coal was delivered by canal boats, and various by-products including coke, tar, sulphur and ammonia were despatched in the same way – special flush-decked canal 'tankers' such as the *Tweed*, *Orwell* and *Umea* being were for the transport of liquid cargoes.

In 1886–87, a short branch railway was constructed between the gasworks and the GWR main line, the principal engineering feature on this new line being a substantial twin-span lattice girder bridge across the River Thames. The new new line was built under the provisions of a private siding agreement dated May 1886 between the Oxford Gas Light & Coke Co. and the Great Western Railway.

The St Ebbe's district had expanded enormously since 1818, and when it became necessary to extend the works the gas company erected new gasholders and other facilities on the south side of the river – by which time the works occupied 19 acres. The 'South Works' was served by an extension of the gasworks internal railway system, which was worked by a small

fleet of industrial tank locomotives – GWR engines were prohibited from entering the gas works sidings. In post-war years there were four gasworks locomotives, all of which had been built between 1906 and 1946.

Oxford gasworks was closed in 1960 and the site was redeveloped. Two large gasholders remained in use for storage purposes at St Ebbe's until 1968, but most of the surviving gasworks' infrastructure was eventually demolished, leaving the railway bridge in situ as a tangible reminder of one of Oxford's first industrial ventures. The Preachers Lane housing estate now occupies part of the northern site, and Gas Street, which was the original entrance to the works, no longer exists. The working-class suburb of St Ebbe's itself, which grew up around the gasworks on the northern bank of the river in the 1820s, was also swept away, many of its former residents being relocated to the newly built Blackbird Leys estate. The Westgate car park now occupies this area, which was once criss-crossed with streets lined with two-up two-down terraced houses.

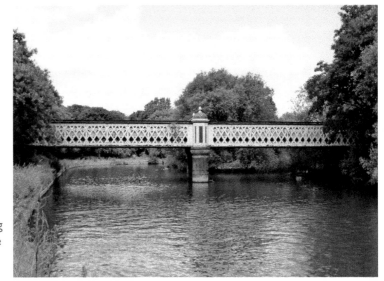

A recent photograph showing the gasworks bridge on 22 June 2018.

A view eastwards along the deck of the bridge, which now carries a footpath to a nearby nature reserve. All traces of industry have been obliterated.

VICTORIAN DEVELOPMENTS

THE IMPORTANCE OF DOMESTIC SERVICE IN VICTORIAN OXFORD

In 1801, Oxford had a population of 11,694. Thereafter, the city's population began to expand more rapidly, rising to 23,834 in 1841, 27,457 in 1851, 37,057 by 1901 and 80,540 by 1931, much of this growth having taken place in new suburbs that had appeared well beyond the confines of the original urban centre. The city was, at the start of the nineteenth century, utterly dependent upon the university, which remained the principal local employer and also the most important local landowner. There was very little industry in Oxford at that time, although transport played an important part in the local economy.

Published in 1852, *Gardner's History, Gazetteer and Directory of the County of Oxford* contains a vast amount of information in relation to the social and economic life of the city and county. In particular, this publication – drawing on the 1851 census – underlines the more or less total lack of industrial employment in Oxford at that time. There were no factories as such, and the only 'industrial' employers were the Great Western Railway, the London & North Western Railway and the Oxford Gas Light & Coke Co., which were undertakings public utilities rather than manufacturing industries. In the absence of staple manufacturers, the city was dependent upon the university to an extraordinary degree.

Domestic service was a major source of employment, many ordinary middle class households having at least one maid to help with household tasks such as washing, cleaning and cooking, while large villas, such as those which would shortly be built in North Oxford, would have several live-in servants. The twenty-four colleges and halls all required varying numbers of college servants, ranging from two at St Alban's Hall, four at St Edmund's Hall, seventeen at Exeter and as many as thirty-two at Christ Church. The average number of servants employed in each college seems to have been around seventeen, which would imply a total of around 400 throughout the university. Most of the colleges had a cook and butler, while others employed a 'manciple' or steward, and Corpus Christi College employed a gardener, in addition to a butler and a cook. In 1911, 26.9 per cent of the Oxford labour force were employed as domestic servants.

There was a wide range of trades within the city, including twenty-eight builders, five boat builders, fifteen saddlers, fourteen straw hatmakers, nine wheelwrights, nine blacksmiths,

seventeen livery stable keepers, seven coach builders, fourteen printers, fifteen bookbinders, twenty-seven booksellers and forty-nine coal merchants and dealers. There were no less than 250 innkeepers and beer retailers, while some of the more unusual trades included umbrella makers, bath chair owners, wheelwrights and tennis court keepers.

VICTORIAN NORTH OXFORD – THE DEVELOPMENT OF A SUBURB

The upper sections of the Victorian middle class had, for many years, been keen to emulate the lifestyle of the country gentry, and these aspirations became much more pronounced as the Industrial Revolution got into its full stride. Successful traders and well-paid professional people started to migrate towards the outskirts of the city in considerable numbers; by the 1850s, for example, there were said to be twenty-three 'gentlemen's houses' in the village of Iffley.

The individuals who resided in these country retreats had no intention of creating new suburbs, but as the demand for out-of-town properties increased, powerful landowners such as the Oxford colleges began to plan ambitious residential developments as a means of increasing the value of their land. St John's College, in particular, was instrumental in laying out the Norham Gardens estate and other areas of North Oxford, which transformed the area to the north of St Giles' into a classic upper-middle-class Victorian suburbs.

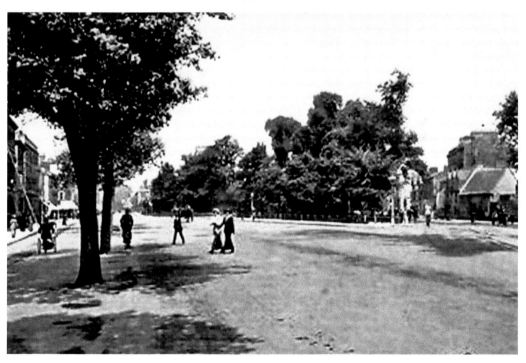

This old postcard view shows the north end of St Giles, looking northwards along the Woodstock Road, with Banbury Road visible on the extreme right. These two roads, which extend northwards for a distance of over 2 miles, have become synonymous with Victorian North Oxford. They are linked by a network of inter-connecting roads which follow an approximate east-to-west alignment, thereby creating an informal grid pattern.

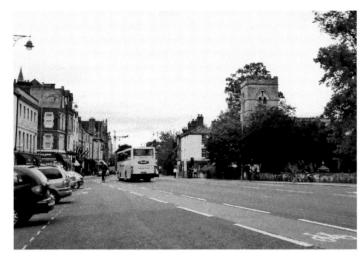

A view northwards along the Woodstock Road in May 2013.

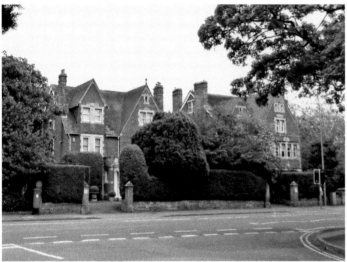

An archetypal North Oxford scene, showing Victorian houses at the west end of Rawlinson Road. These relatively large houses were designed and built for upper-middle-class occupants, many of whom would have employed up to half a dozen domestic servants.

Typical Victorian villas in Norham Gardens, photographed in 2012.

THE WALTON MANOR ESTATE, NO. 113 WOODSTOCK ROAD

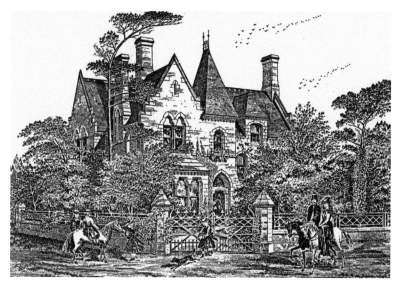

In 1859 St John's College had set up a committee to consider how an area of college land to the west of the Woodstock Road could be profitably developed. Samuel Seckham was selected as the first architect, but he was subsequently replaced by the Witney architect William Wilkinson (1819–1901), who designed a number of the new houses including No. 113 Woodstock Road, which was built in 1863 for Edwin Butler, a wine merchant.

Victorian architecture was hated and despised by mid-twentieth-century town planners and their friends in the architectural establishment, and in these circumstances many of the large North Oxford houses were threatened with destruction during the 1960s, one of the victims being No. 113, which was demolished in the 1960s. Its site is now occupied by a modern development known as Butler Close.

WILLIAM WILKINSON & THE NORHAM MANOR ESTATE

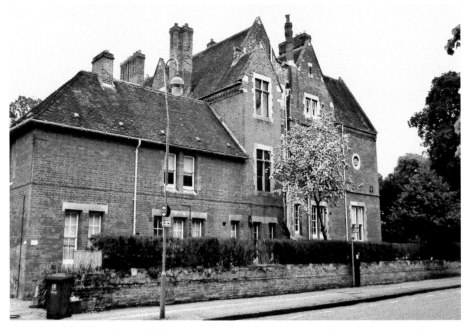

Laid out by local architect William Wilkinson on land owned by St John's College, the neighbouring Norham Manor Estate was built in the 1860s as a residential suburb for wealthy tradesmen and professional people. Wilkinson designed several of the villas himself, while in his role as superintending architect he was able to ensure uniform standards throughout the new estate. Most of the houses were of red- or yellow-brick construction, with prominent stone dressings.

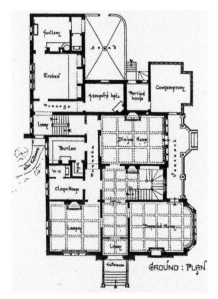

Wilkinson subsequently published a book entitled *English Country Houses*, which contained plans and drawings of recently erected domestic properties, one of these being No. 13 Norham Gardens, a showpiece villa on the Norham Manor estate. The accompanying ground plan reveals that, in addition to the dining room, library, conservatory, potting house and lobby, the accommodation included a butler's room and a servants' hall. The implication was that a house of this size would require perhaps half a dozen servants.

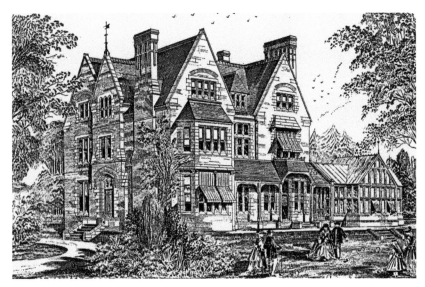

This illustration from *English Country Houses* shows No. 13 Norham Gardens from the south-west. The drawing room, dining room and conservatory faced south to ensure maximum sunlight. On 16 October 1869 *Jackson's Oxford Journal* reported that this residence, which was being built for Thomas Dallin MA, a Fellow of Queen's College, was 'the largest on the estate', and the work 'was being carried out in a very substantial manner, with red brick faced with light-coloured stone'.

No. 13 later became the home of Canadian physician William Osler (1849–1919), a Fellow of Christ Church College and Regius Professor of Medicine at Oxford, and his American wife, Grace Renée. The Oslers enlarged the house and altered its appearance; the 1911 census reveals that they had five live-in servants including a butler, cook and maids.

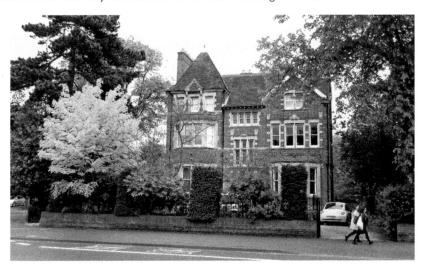

A typical Victorian villa in the Woodstock Road. A large house of this kind would originally have accommodated a single middle-class family (and their complement of servants), whereas in more recent years many of these nineteenth-century buildings have been adapted for use as university offices or student lodgings.

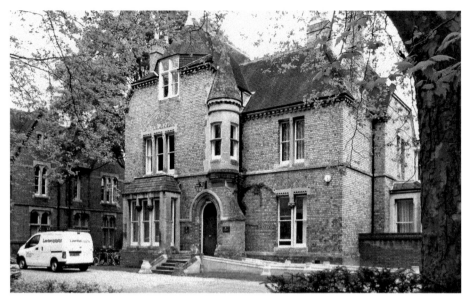

No. 60 Banbury Road, at one time known as 'Shrublands', was another typical North Oxford villa. It was designed by William Wilkinson and the first occupant was Thomas George Cousins, the proprietor of a chemists shop in Magdalen Street. The house is attractively constructed of yellow brickwork with Bath stone dressings, and when first built in 1869 it contained three reception rooms, five bedrooms and a conservatory, as well as a kitchen, cellars and other service rooms. This Victorian Gothic villa is now an integral part of Kellogg College, a constituent college of the University of Oxford.

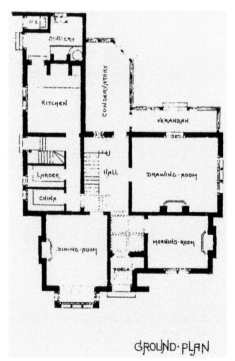

GROUND·PLAN

The original ground plan of No. 60 Banbury Road. Study of the plan will reveal that, as usual with William Wilkinson's large villas, the kitchen, scullery, larder and other service rooms were laid out in such a way that the servants could go about their daily work without impinging unnecessarily upon the master or his family – a servants' passage was provided alongside the main hallway. The servants had their own entrance, and their quarters were entirely separate from those of the family. There was, moreover, just one connecting doorway between the two parts of the house, this being situated in the hall.

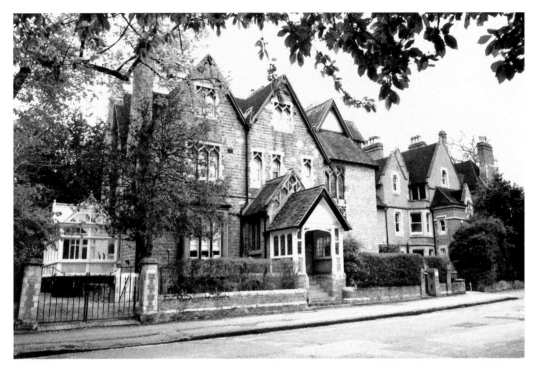

No. 3 Norham Gardens was designed by Charles Buckeridge (1832–73). Built in 1868 for Henry Hammons, a bookseller, the house is of yellow brickwork with distinctive fenestration and an unusual 'stepped' porch.

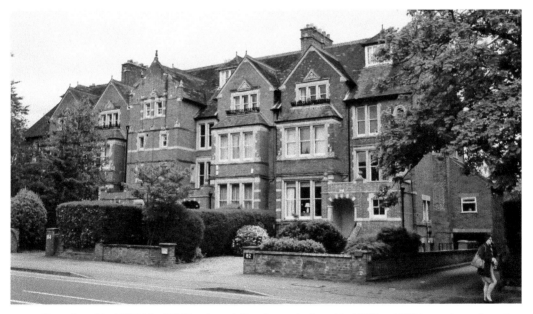

Completed in 1887, No. 82 Woodstock Road was designed by William Wilkinson in conjunction with his nephew Harry Wilkinson Moore – the two architects having formed a partnership in 1881. William Wilkinson retired in 1886 and, thereafter, his nephew worked alone.

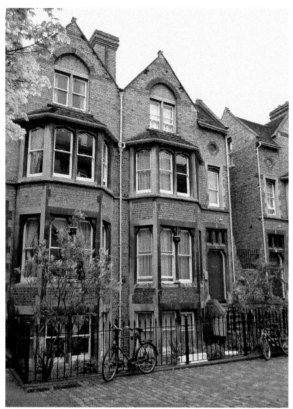

No. 22 Museum Road and the neighbouring properties were erected in 1873 as a speculative venture by John Dorn, a local builder. The most noteworthy occupant of No. 22 was perhaps Frederick Gaspard Brabant (1856–1929), a writer, teacher and private tutor who, as an undergraduate, had 'attained the rare distinction of adding a first in mathematical moderations to two firsts in classics'. According to his obituary, which was published in *The Times* on 15 March 1929, he was 'one of the best known, and certainly the most distinguished of Oxford coaches ... his teaching was painstaking and thorough, and almost universally successful'. F. G. Brabant was also an enthusiastic local historian who produced a number of informative guidebooks about Oxfordshire, Berkshire, Sussex, North Wales and the Lake District.

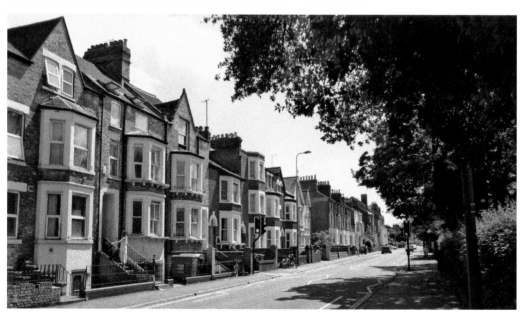

Large Victorian villas were not confined to leafy North Oxford. These substantial Victorian houses would seem, at first glance, to have many affinities with the nineteenth-century villas in North Oxford, although they are in an urban setting beside the busy Iffley Road.

In addition to its prosperous middle-class residential areas, Victorian Oxford contained several working-class enclaves, notably the district of high-density terraced housing known as 'Jericho', and the much later suburban developments in and around Summertown. Jericho, which is thought to have derived its biblical name from a long-established inn known as Jericho House, is situated between Walton Street and the Oxford Canal, and it once housed workers employed by local businesses such as the railway, the Eagle Ironworks and the Oxford University Press. The photograph, taken in 2012, is looking along Cardigan Street towards St Barnabus' Church. The entire area was once threatened with redevelopment but, happily, the closelyspaced Victorian cottages have survived and are now much sought after.

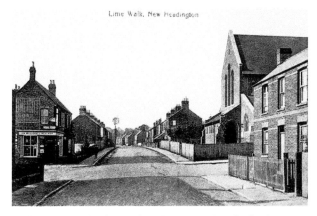

Lime Walk, New Headington

Suburban encroachment took place elsewhere in the Oxford area, notably around Headington and Cowley, although the period of greatest expansion in south and east Oxford occurred during the twentieth century, following the establishment of the Morris Motors Works and the neighbouring Pressed Steel factory. The growth of the city was accompanied by various boundary changes as the new suburbs and former rural villages were absorbed; St Clements parish, for example, was incorporated into the city of Oxford in 1835 under the provisions of the Municipal Corporations Act, while the villages of Headington, Cowley and Iffley were swallowed up during the twentieth century. Meanwhile, a similar process was taking place to the west of Oxford, where several parishes and districts that had formerly belonged to Berkshire were absorbed into the city.

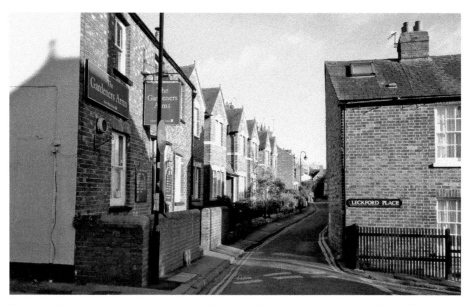

Running from east to west between Woodstock Road and Kingston Road, Plantation Road was laid out in the 1830s on the alignment of two earlier country lanes. As its name implies, Plantation Road once gave access to an area of land used as nursery gardens, and the road retains much of its rural character. This photograph is looking eastwards from the junction of Leckford Place and St Bernard's Road, with No. 39, The Gardener's Arms public house, visible to the left. This pub is thought to date from the 1830s, its chief claim to fame being that Bill Clinton, the future President of the United States, is said to have frequented the pub when he lived at nearby No. 45 Leckford Road.

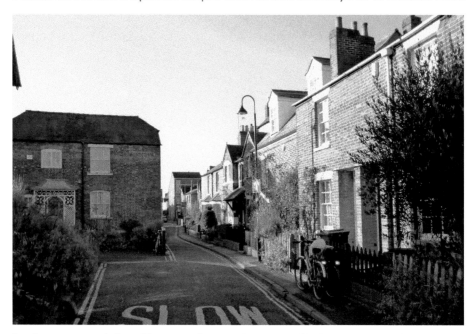

Looking westward along Plantation Road in December 2012.

Running from north–east to south–west, Divinity Road was laid out by the Oxford Industrial & Provident Land & Building Society in 1891. When first erected, these neat, brick-built villas would typically have been occupied by bank clerks, shopkeepers, small businessmen and other lower-middle-class residents. Many of these households would have employed non-resident general maids, who would today be called home helps.

No. 217 Woodstock Road was one of a pair of villas erected in 1900. Gothic architecture had gone out of fashion by the end of the Victorian period, and early twentieth-century houses tended to exhibit vernacular revival features, such as tile-hung bay windows and Tudor-style timber framing. The first occupant of No. 217 was Mrs Frances Richardson, the wife of a clergyman.

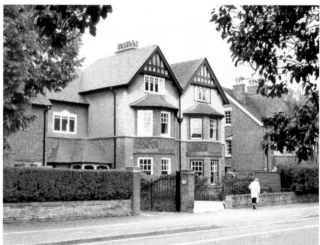

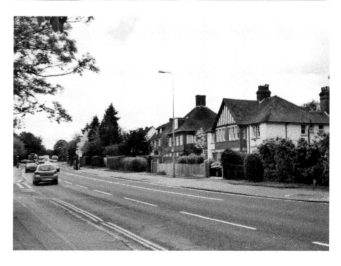

Vernacular revival-style houses at the north end of the Woodstock Road, near the junction with Davenant Road.

THE EXPANSION OF THE CITY

INNS & HOTELS

As we have seen, transport facilities have played an important part in the development of Oxford. In addition to its railways and waterways, the city has benefited from the availability of road transport links, the road from London to Oxford being part of a major highway between London, Gloucester and Milford Haven. Maintenance of this great artery of communication between England, Wales and Ireland was, at first, entrusted to the parishes through which it passed, though in 1714 an Act was passed enabling trustees to collect tolls in order to pay for much-needed repairs and maintenance.

Improved standards of highway maintenance and construction during the early nineteenth century led to an upsurge in traffic on the Oxford Road, and by the 1830s it had emerged as one of the most important stagecoach routes in the country. Prestigious coaches such as *The Age* covered the 55 miles between London and Oxford in only three hours forty minutes, and drivers such as Joe Tollit achieved legendary reputations in their own lifetimes.

Prior to the introduction of railways, the stagecoaches and other passing traffic brought welcome prosperity to coaching towns such as Oxford, which had a number of coaching inns, most important of which were The Angel, the King's Arms, The Mitre, the Roebuck and The Star.

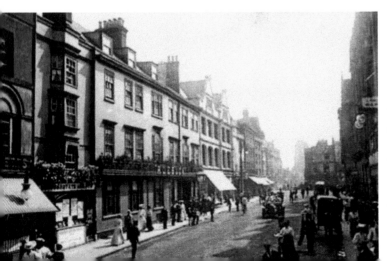

The Roebuck Hotel as depicted in an Edwardian postcard view. This former coaching inn later became Oxford's first Woolworths store.

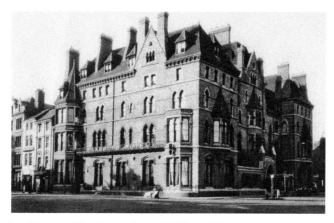

Above and below: Designed by the architect William Wilkinson, the Randolph Hotel is an archetypal Victorian grand hotel in the Gothic style, with its main entrance in Beaumont Street. It is of yellow-brick construction with stone dressings and a steeply pitched hip roof. The hotel was completed in 1864, although an extension was added in 1952, by which time the hotel had over 100 bedrooms. It is interesting to note that William Wilkinson spent his declining years in the Randolph, the unmarried architect having taken a suite of rooms in one of his finest buildings.

The hotel narrowly escaped destruction on the night of 15 December 1874 when a major fire broke out in Messrs Collins neighbouring carriage-maker's workshops. Six fire engines were soon on the scene and an urgent request was telegraphed to the waterworks, but there was insufficient water pressure for the hoses. Unchecked, the fire made astonishing progress, but Mr Blake, the Randolph's engineer, was able to run a hose from a large water tank at the very top of the building and, with the aid of an engine, he was able to pump a jet of water onto the outside wall of the hotel and extinguish a small fire that had started in the window frame of room No. 183.

Meanwhile, policemen and volunteer firemen were rescuing people from the threatened properties – one unfortunate lady being so terrified that she had to be dropped from a first-floor window and caught in a 'jumping sheet' held by nine or ten men. The fire was finally extinguished about twenty-four hours later, by which time several shops and business premises had been gutted. The worst damage occurred in the carriage-makers yard where over 100 vehicles had been destroyed.

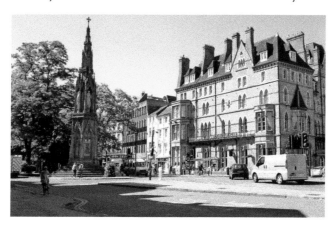

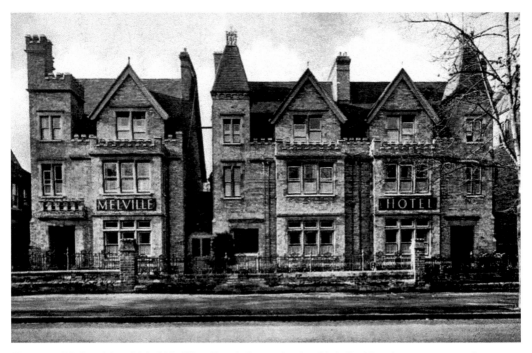

Above and below: Nos 214–218 Iffley Road, formerly the Melville Hotel, are now used as student accommodation. Advertisements reveal that in the mid-1930s the Melville Hotel had thirteen double or twin rooms; bed-and-breakfast was available from 7s 6d, while the cost of an evening meal was 3s 6d.

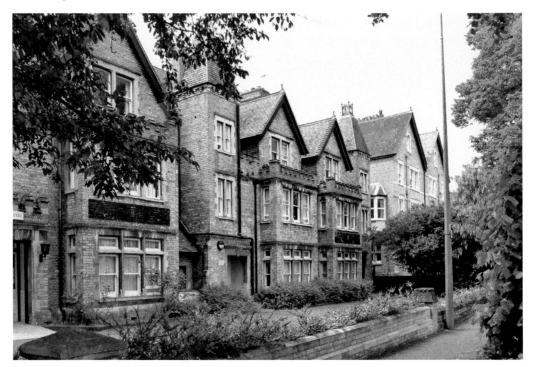

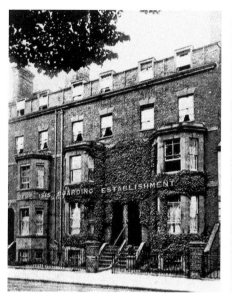

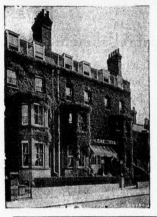

OXFORD.

THE ISIS

PRIVATE AND RESIDENTIAL HOTEL,
47-53, Iffley Road

P LEASANTLY Situated, over- looking Christ Church Cricket Ground. Con- venient for Colleges and River.

Private Sitting Rooms if required.

GARAGE.

Terms Moderate.

Telephone **2776.**

Apply MANAGERESS.

Above left and right: Taking its name from the nearby Upper Thames, the Isis Hotel, Nos 47–53 Iffley Road, was commandeered by the Inter-Service Topographical Department during the Second World War – ISTD was a branch of naval intelligence which specialised in the provision of topographical intelligence for the British armed forces. The hotel, which was said to be 'pleasantly situated overlooking Christ Church Cricket Ground', housed female (Wren) typists of the ISTD. Post-war editions of the *RAC Guide & Handbook* show the Isis as a thirty-four-bedroom hotel.

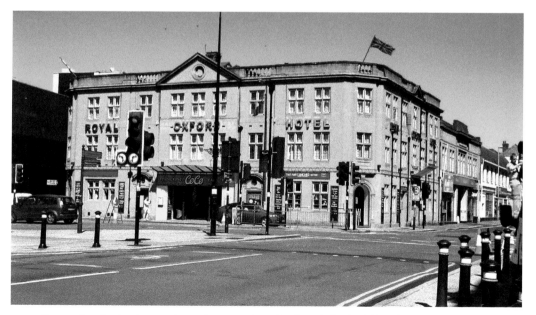

Conveniently sited near the railway station, the Royal Oxford Hotel in Park End Street is a comparatively modern hotel, having been built in the 1930s on the site of the Robin Hood pub, the Five Alls Inn and the Railway Hotel. It has twenty-three bedrooms.

OXFORD'S STREET TRAMWAYS

The first British street trams were introduced in the 1860s by the Chicago-born entrepreneur George Francis Train (1829–1904), who imported these characteristic American-style vehicles in parts and assembled them in Birkenhead. His business associate George Starbuck established a tram factory in Birkenhead, and horse-drawn tramcars of the same general design were supplied to operators in Britain and Europe. Modern visitors may be surprised to learn that Oxford once had a 4-ft gauge street tramway system, the City of Oxford & District Tramway Co. having been formed in 1879 with an authorised capital of £42,000. The directors included G. C. Taylor, C. W. Wallis and F. J. Horrocks, while the registered offices were in east London. Oxford, with its level streets, was regarded as an ideal location for a horse-drawn tramway, while there was an obvious requirement for public transport facilities, as a large part of the population lived in residential suburbs outside of the city centre.

The first tramline was opened from the GWR and L&NWR railway stations to Cowley Road via Park End Street, Carfax and High Street, on Thursday 1 December 1881, and a second route was brought into use between Carfax and the Banbury Road in 1882. The Walton Street branch was opened from St Giles' to Leckford Road on 15 July 1884, and a line from Carfax to Lake Street, via Cornmarket and Folly Bridge, was added in 1887. The network was completed in 1898, when the Banbury Road line was extended to South Parade. At its fullest extent the Oxford tramway system encompassed a route length of 6¼ miles, while the trams carried around 3 million passengers per annum.

The tramlines were mainly single track with intermediate crossing loops, the rails being sunk into the surface of the roadway. The original tramcars were four-wheeled single-deckers, built by the Starbuck Car & Wagon Co. of Birkenhead. Some of the Starbuck cars were subsequently rebuilt as double-deckers with passenger seats on the upper deck, while additional double-decker cars were acquired in order to deal with growing traffic requirements. The

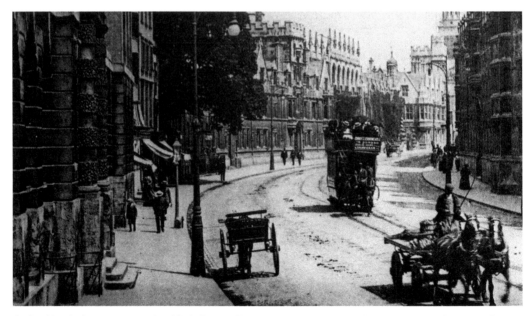

A double-deck tramcar in the High Street. There were no intermediate stopping places, and passengers were able to board the trams at any convenient point.

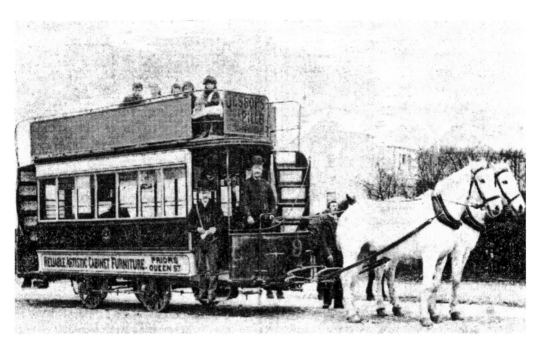

A detailed view of double-deck tramcar No. 9. The person standing behind the horses was Elias Cooper, who worked for the tramway company as an ostler.

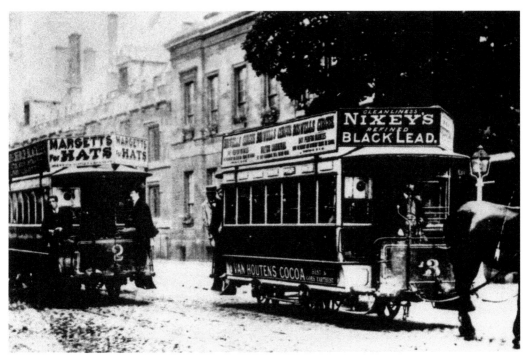

A glimpse of tramcars No. 2 and No. 7. By 1910 there were nineteen cars, together with 150 horses. The main depot and car shed, which was established in Leopold Street, near the Cowley Road terminus, had five tracks.

Above: Electrification schemes were opposed by 'conservationists' who objected to the use of obtrusive overhead wires in Oxford's historic streets. By the beginning of the twentieth century postcards were portraying the horse trams as obsolete relics of the Victorian age. It is perhaps ironic that if the horse trams had remained in operation they would now be regarded as a major tourist attraction!

Left: Following the abandonment of the system in 1914 many of Oxford's tramcars ended their days as hen houses and garden sheds including a vehicle that was discovered on a farm at Yarnton and subsequently transported to East Hanningfield in Essex as part of an abortive preservation attempt.

double-decked vehicles could carry forty-six passengers, although on occasions such as Eights Week many more people would scramble aboard. Photographic evidence suggests that the double-decker cars were normally pulled by two horses, whereas the lighter Starbuck trams required just one horse.

At the start of the twentieth century Oxford tram drivers were paid 21s for a sixty-five-hour week, while conductors earned 17s. 6d. Out of these meagre earnings they were expected to provide their own whips and protective clothing, while conductors were held responsible for all fares, and they had to 'make up all the bad money that Oxford people palmed off on the trams'. Under these circumstances it is perhaps hardly surprising that in 1913 the tramway workers, having formed a branch of the National Vehicle & Tramway Workers Union, decided to take industrial action; fifty-six employees joined the strike, and in so doing they contributed to the demise of the tramway in the following year.

ELLISTON & CAVELL – OXFORD'S MOST PRESTIGIOUS DEPARTMENT STORE

As its name implied, Elliston & Cavell were a partnership between Jesse Elliston, the proprietor of a draper's shop at No. 12 Magdalen Street, and his brother-in-law John Caldecott Cavell (1813–87), who had married Sarah Elliston, Jesse's sister, in 1835. Elliston made Cavell a partner and, thereafter, the firm became known as Elliston & Cavell. In 1853, Jesse Elliston dropped dead while walking to his home in Somertown, while Sarah Elliston died in 1856. In

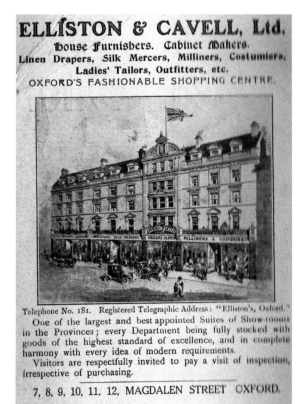

The impressive façade of Elliston & Cavell's shop in Magdalen Street.

ELLISTON and CAVELL,

BEG TO ANNOUNCE THAT THEIR

ANNUAL WINTER DRAPERY SALE

IS NOW IN PROGRESS,

And will be continued until JANUARY 20TH.

IN VIEW OF THE

EXTENSIVE ALTERATIONS AND ADDITIONS

To their existing Premises and in consequence of the damage to Goods likely to be caused by the demolition of the adjoining buildings, they are, upon this occasion, offering their Stock at exceptional prices.

In every Department the Stock has been re-marked and large reductions made, with the object of effecting as large and speedy a clearance as possible.

All Goods are marked in Plain Figures and a DISCOUNT of ONE SHILLING in the Pound is allowed off all Cash Purchases above Five Shillings.

Close during the Sale at 7 o'clock, and on Saturdays at 5 o'clock.

11 & 12 MAGDALEN STREET, OXFORD.

An Elliston & Cavell advertisement dating from 1894, at which time the store was undergoing an ambitious reconstruction scheme.

1861, John Caldecott Cavell married his widowed sister-in-law Harriet Delf (née Elliston) and at the time of the 1861 census the couple were living above the shop in Magdalen Street with nineteen shop assistants, two shop clerks, three porters, one housekeeper and five servants.

James Cavell served as mayor of Oxford in 1865–66, 1877–78, and a for a short time in 1879–80. He was the chairman of the Oxford Building and Investments Co. until 1882, but died in tragic circumstances some five years later, having fallen out of his bedroom window in Magdalen Street on the night of 2 February 1887.

Elliston & Cavells eventually became the largest department store in Oxford. The store, which was extensively rebuilt in 1894, was lavishly decorated, with a sweeping staircase and a mural depicting deer in a forest glade. The ladies' powder room had basins in the shape of marble swans with gold taps, while shop assistants in black uniforms provided dry towels. The shop was taken over by Debenhams in 1953, but the original name was retained for another twenty years. The former Elliston & Cavell building still forms part of the present-day Debenhams store.

BREWERS & BREWERIES

In the early years of industrial development breweries such as Hall's Oxford Brewery and Morrell's Lion Brewery were, in many cases, the most technically advanced industries in the country. They were among the first industrial plants to introduce steam power – for example, the first two steam engines set up in London were at breweries. Brewing was, for many years, carried out on a small scale, many pubs having their own brewing equipment, while the

Oxford colleges had traditionally brewed their own beer. It has been suggested that in the early fourteenth century Oxford had 115 brewers for a population of around 10,000, while over 130 households were involved with brewing in 1311.

In 1852 the city could boast seven maltsters and thirteen brewers, while in the mid-Victorian period there were were nine breweries of varying sizes in Oxford, together with thirteen brewers' agents, who imported beer in from elsewhere. The nine breweries in operation at that time were:

Flowers & Co. Brewery, Cowley Road
Hall's St Giles' Brewery
Hall & Co., the Swan Brewery, Paradise Street
Hanley's City Brewery, Queen Street
Le Mills's Brewery, St Ebbes
James Morrell's Lion Brewery, St Thomas Street
Simonds's Brewery, Queen Street
Weaving's Eagle Steam Brewery, Park End Street
Messrs Wootten & Coles, St Clement's Brewery

Morrell's and Hall's were, by that time, probably the most important breweries in the city. The history of these brewing families is very complicated, suffice to say that Hall's, who were based in the Swan Brewery in Paradise Street, were originally known as Messrs Hall, Tawney & Taylor, The business was known as Hall & Co. after the death of Charles Taylor in 1853, but in December 1896 Hall A. W. & Co. were incorporated as a limited company, which traded as Hall's Oxford Brewery Ltd. The company, which owned numerous tied pubs, was valued at £549,891 in 1899. Sadly, the independent history of Hall & Co. was rather short, in that the undertaking was taken over, together with around 300 licensed houses, by Samuel Allsopp & Sons of Burton-on-Trent in 1926, and brewing ceased in that same year.

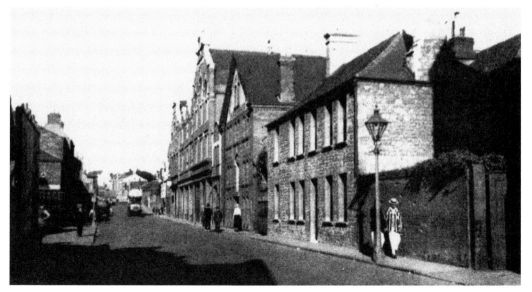

A *c.* 1919 view of Park End Street looking east towards the city centre. The large building in the centre of the picture was a furniture repository, next to which was Hall's Oxford Brewery and Hayter's blacksmith's shop.

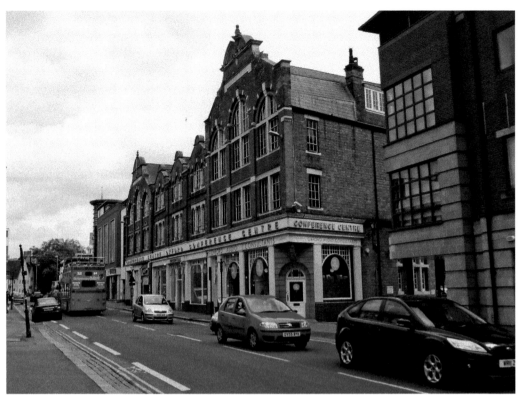

Above: The former furniture repository has survived, and it is now used as a conference centre, but the site of the brewery has been redeveloped.

Left: A contemporary advertisement extolling the virtues of Hall's Oxford Ales.

OXFORD ALES AT THE PARIS EXHIBITION,
1889.
HIGHEST AWARD.

The GOLD MEDAL for PALE ALE,
AND
The GOLD MEDAL for ENGLISH MALT,
HAVE BEEN AWARDED
TO
MESSRS. HALL & CO.,
SWAN BREWERY, OXFORD.

Season-brewed Ales, are now ready for delivery, of highest quality and at the following Prices :—

	PER KILDERKIN.	PER BARREL.
East India Pale Ale	25s.	50s.
Stock Ditto	27s.	54s.
Golding-Hop Pale Ale	18s.	36s.
Stock Ditto	21s.	42s.

Double Stout for Invalids, at 12s. 6d. per Firkin, 9 Gals.

Agent for WOODSTOCK HENRY LOCK.

LONDON STORES—
The Grove, Hammersmith.

A selection of twentieth-century beer labels including four Morrell's labels and one example from Hall's of Oxford.

LION BREWERY, OXFORD.

OWING to the increasing demand for the Celebrated ALES and STOUTS brewed by

MESSRS. MORRELLS' TRUSTEES,

A Town Office has been opened for the convenience of the Public at 142, HIGH STREET, OXFORD (close to Carfax), where orders for

CASKS OR BOTTLED BEERS

As per price list, will have immediate attention. Small quantities of Bottled Beers, from 1 dozen upwards, may be obtained.

PRICE LIST.

BITTER ALES.

	Brl.	Kild.	Firk.	Pin.
Best Bitter Ale	53s 0d	26s 6d	13s 3d	6s 9d
India Pale Ale				
Brewed specially for family use.	42s 0d	21s 0d	10s 6d	5s 3d
Light Dinner Ale.. ..	36s 0d	18s 0d	9s 0d	4s 6d

MILD ALES.

	Brl.	Kild.	Firk.	Pin.
Old Strong, XXXX ..	63s 0d	31s 6d	15s 9d	8s 0d
Best XX	53s 0d	26s 6d	13s 3d	6s 9d
Best X	42s 6d	21s 3d	10s 6d	5s 3d
Ale	32s 0d	16s 0d	8s 0d	4s 0d
Stout	53s 0d	26s 6d	13s 3d	6s 9d

BOTTLED BEERS.

	Imp. pints.	Half-pints.
India Pale Ale	3s 6d	1s 9d
Nourishing Stout	3s 6d	1s 9d
Old Strong XXXX..	4s 6d	
Light Dinner Ale (pints only) ..	2s 6d	

The Town Office is in communication with the Brewery by a private Telephone, and all deliveries will be executed with the utmost promptitude.

All letters to be addressed to

THE MANAGER,

MORRELLS' TRUSTEES,
LION BREWERY, OXFORD.

An example of Morrell's publicity material from the late Victorian period advertising various products of the Lion Brewery, including bitter, mild and bottled beers.

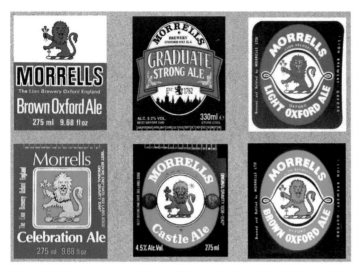

Above left: Another assemblage of Morrell's beer labels. Many of the company's products had a university theme, an example shown here being the Graduate Strong Ale label.

Above right: An unopened bottle of Morrell's Celebration Ale, dating from the 1970s.

Although Morrell's Lion Brewery has now been converted into residential accommodation, many of the former buildings have been retained, as exemplified by these views taken in St Thomas Street on 22 June 2018.

Above: The brewery entrance showing the ornate gateway with its two lions.

Right: A detailed view showing the decorative chimney at Morrell's Lion Brewery, which dates from around 1901.

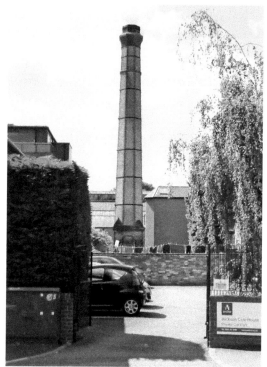

Morrell's had been founded in 1743 by Richard Tawney, who later formed a partnership with Mark Morrell (1771–1843) and his brother James Morrell (c.1773–1855). The two brothers moved from their home in Wallingford to Oxford in 1797, and after Tawney's death in 1800 the trustees of his estate signed over to them the lease of the brewery premises in St Thomas Street from the ground landlord, Christ Church, with the freeholds of a malthouse and nine tied public houses.

The brewery greatly increased its output under the ownership of the Morrell brothers, while the firm continued to increase the size of its tied estate. The Lion Brewery was improved and expanded at various times, a large brewing shed being added in 1879, while a new engine house was built in the 1880s, together with a new yard and stables, a blacksmith's shop and new offices. A steam engine that had been built for the brewery as long ago as 1826 remained in use until 1964, and it is now preserved at the Abbey Pumping Station in Leicester.

Meanwhile, the Morrell family had erected a palatial house known as Headington Hill Hall, where they lived in considerable style. Their land extended over both sides of Headington Road and in 1866 William Wilkinson was asked to design an ornamental footbridge, which still survives as a prominent local landmark. The Morrrell family included Philip Morrell (1870–1943), who served as a Liberal MP from 1906 until 1918 and was married to the literary hostess Lady Ottoline Morrell (1873–1938), who held court at nearby Garsington Manor.

The brewery was run by a family trust for many years, but in 1943 Morrell's Brewery Ltd was registered in order to acquire the business from the trustees; the capital of the new undertaking was £300,000, while James 'Jimmy' Morrell (1882–1965) was the chairman. In later years Jimmy Morrell resisted many takeover bids, and worked hard to preserve the independence of the brewery, which was, by that time, the only one still brewing in Oxford. He died in July 1965 and his eldest son, Colonel Herbert William ('Colonel Bill') James Morrell, succeeded him, first as managing director, then as the chairman of Morrell's Brewery Ltd.

Sadly, the brewery was closed in 1998 following an acrimonious family dispute. the beer brand's names were taken over by the Thomas Hardy Brewery in Dorchester, while most of the Morrell's tied pubs were sold to Greene King in 2002. An attempt to get the Lion Brewery listed was unsuccessful, and the brewery site in St Thomas Street has now been redeveloped as a residential complex.

JOHN ALLEN'S OF COWLEY

At the end of the nineteenth century Oxford had two relatively important engineering firms, one of these being Lucy's Eagle Ironworks of Jericho while the other was John Allen's of Cowley. The latter firm traded under several names, including included Edison & Nodding, the Oxford Steam Plough Co. and John Allens – Messrs Edison & Nodding having been acquired by John Allen in 1897, and then renamed The Oxford Steam Plough Co The name later reverted to John Allen & Sons Ltd – although it was known locally as the Oxford Steam Plough Co. for many years before becoming John Allen (Oxford) Ltd.

The company were steam ploughing, steam rolling and steam threshing contractors, and they also built steam engines, fairground rides and agricultural equipment such as the 'Allen scythe'. The firm, which had around 200 employees by 1900, owned a large fleet of steam engines, one of these being the roller shown in the accompanying illustration (overleaf). Although the engine sports the Allen's 'ox-and-ford' badge, this particular steam roller was in fact made by Ruston's of Lincoln. The company was eventually taken over by Grove, the American crane manufacturer, who shut down the works in 1980.

One of Allen's steamrollers.

LUCY'S EAGLE IRONWORKS

The 1852 *Gardner's Directory of the County of Oxford* lists a dozen or so miscellaneous manufacturers, most of which would have been small-scale operations (one of these being Charles Grafton, who was described an an 'iron founder', based at the 'Eagle Foundry' in Jericho). The firm was originally founded by William Carter, an ironmonger, who established a factory beside the Oxford Canal in 1825. Carter later moved to Leamington, but his partner William Grafton remained in business at the foundry, which specialised in the production of cast-iron building components such as pipes and lamp posts, together with ornamental ironwork for gates, railings, verandas and balconies. Following Grafton's death in 1861 his partner, William Lucy, took over, and on Lucy's death in 1873 the name Lucy's was adopted by the company.

During the 1870s and 1880s Lucy's provided ornamental and structural ironwork for the expanding suburbs of Oxford. In 1879 Lucy's was taken over via a joint stock company operated by Charles Kelly and partners and the product range was expanded to include library shelving and other steel components. Munitions were produced during the two world wars, while the company also manufactured switchgear and other electrical engineering equipment. The Eagle Foundry was closed in 2002 and its canalside site redeveloped with residential apartments. The company is now based in Dubai.

Apart from one office block there are few reminders of the once busy Lucy's Foundry, although two eagle-topped gateways have been left in situ including this example in Juxon Street.

TWENTIETH-CENTURY DEVELOPMENTS

THE CITY OF OXFORD MOTOR SERVICES

In 1906, an undertaking known as the City of Oxford Electric Traction Company was formed with the intention of electrifying the Oxford tramway system, but local opinion had turned against the trams. Opposition to the electric tramway scheme was led by William Morris, the future Lord Nuffield, who introduced an unlicensed motor bus service on 5 December 1913 – passengers wishing to avail themselves of the service were asked to purchase travel coupons from selected shops as no money could be taken on the unlicensed buses. This forced the council's hand, and in January 1914 it was agreed that licenses would be granted to Morris and other bus operators, including the tramway company, which had already introduced its own bus services. Having made his point, William Morris withdrew his buses and the tramway company thereby became a motor bus operator – the street tramway being abandoned in 1914.

AEC Renown double-decker bus No. 368 at Oxford station in 1972.

A Regent bus at Oxford station in 1971. These 1970s photographs provide a visual reminder of the distinctive maroon and purple-brown City of Oxford Motor Services bus livery.

A present-day Oxford City Bus stands outside Queen's College in the High Street.

This Scania bus, seen in Banbury Road in July 2012, illustrates the current Stagecoach Gold livery.

An electro-diesel vehicle in 'environmental green' livery, again in Banbury Road.

Two City double-decker buses and a Stagecoach single-deck vehicle are pictured at Oxford railway station in December 2012.

Oxford buses and trams have utilised several ticketing systems over the years including traditional punch tickets, which were issued by conductors from portable ticket racks. In more recent years machine-issued tickets have predominated, such as the Setright tickets shown here. At one time, Oxford bus tickets were printed on different colour paper according to their fare values, although the machine-issued one were normally printed on green or yellow rolls. The buff-coloured 1½d ticket that can be seen on the right was issued in 1941.

To prevent confusion, the name City of Oxford Motor Services was adopted in 1921. The buses initially operated in and around Oxford, but a network of rural services was soon introduced, one of the first being a service between Oxford, Woodstock and Chipping Norton, which started in August 1919. In May 1920 the company introduced a service between Oxford, Eynsham, Witney and Burford, and this soon became one of the busiest country routes, despite railway competition. Further routes were introduced to cater for the eastwards expansion of Oxford, some of the existing routes being extended, while new services were introduced for the benefit of people living in villages and suburbs such as Cowley, Iffley and Headington.

In the early 1930s the City of Oxford Motor Service drivers earned around 1s 3d a day for a fifty-four-hour week, while the corresponding wage for conductors was 1s. Shift work was the norm, although the length of the actual day varied according to operational requirements.

In 1930 the Great Western Railway acquired a 49 per cent interest in the City of Oxford Motor Services, which was, thereafter, regarded as a 'railway associated' bus company. Nationalisation in 1969 was followed by privatisation in the 1980s, the result being a fragmented industry in which the Oxford Bus Company operates the city services, while Stagecoach has acquired the rural routes to destinations such as Eynsham, Witney and Woodstock.

FRANK COOPER'S OXFORD MARMALADE

Frank Cooper's Oxford marmalade business was founded by Frank Cooper (1824–1927), the son of an Oxford grocer and tea dealer. Having prospered as a grocer, Frank's father moved the family business into the former Angel Hotel, which had once been one of Oxford's foremost coaching inns – the shop being set up in the former coffee room of the hotel at No. 84 High Street. Frank Cooper inherited the business following the death of his father in 1862. The recipe for the famous Oxford marmalade is said to have been perfected by Frank's wife Sarah Jane Cooper, the product being so popular that in 1902–03 a new marmalade factory was built in Park End Street in order to satisfy the growing demand.

Designed by the Oxford architect Herbert Quinton and built by Thomas Kingerlee, the new factory had separate floors for cutting fruit and bottling the finished product, while the third floor included a separate cloakroom and staff dining room for employees. Boiling of the marmalade and jam was carried out in a separate building at the rear of the main factory. In all, the four-storey factory provided 1,630 square feet of floor space.

The business was reconstituted as a limited company in 1913, but the firm remained family owned for many years. It is interesting to note that twelve tins of Oxford marmalade accompanied Captain Scott on his expedition to the Antarctic. The company remained independent until the early 1960s, when it merged with Brown & Polson Ltd, who opened a purpose-built factory at Wantage, thereby severing the manufacturing link between Cooper's marmalade and Oxford. The former Frank Cooper's factory in Park End Street has now been redeveloped as The Jam Factory.

The former Frank Cooper's marmalade factory occupies a corner site at the junction of Hollybush Row and Park End Street.

THE SAGA OF OXFORD WOOLWORTHS

In 1925 the former Roebuck Inn at No. 8 Cornmarket Street became Oxford's first Woolworths store. F. W. Woolworth, which had originated as an American-based company, sold a vast range of goods at bargain prices. The company had a store in virtually every major town and city in the country. The Oxford branch was so successful that the company decided to construct a much larger 'superstore' on a nearby site, and in 1930 the Clarendon Hotel was purchased to provide room for the new building. This prompted a protracted planning dispute with the local authorities, who rejected a number of proposed designs. It was officially suggested that a large new shop would create major traffic problems in an already-congested city centre, but at the same time it was rumoured that the city authorities felt that the proposed new Woolworth building would be too down market and out of place in a historic location such as Oxford.

At length the eminent Scottish architect and town planner Sir William Holford (1907–75) was called in to the create a 'Woolworths worthy of Oxford', and after twenty-seven years of delays and procrastinations a huge new store was finally opened on 18 October 1957. The new building had a uncompromisingly modern appearance, but it was substantially built, with a façade of squared rubble and infill panels of grey slate. Internally, it contained new displays, a deluxe cafeteria and offices, together with a roof garden and a multistorey car park.

In the event the new Woolworths was destined to have a very short life, and the shop was closed in 1983, bringing to an end Oxford's somewhat troubled relationship with F. W. Woolworth & Co. The building has nevertheless survived, and it now houses the Clarendon Shopping Centre and a Gap clothing store.

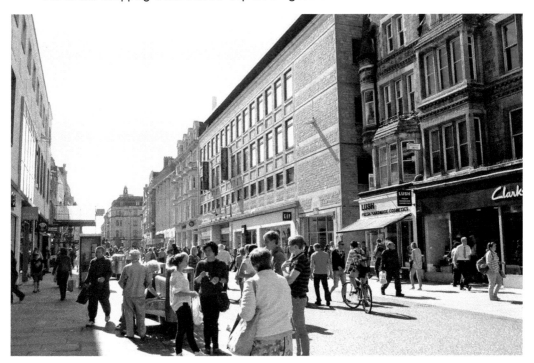

A recent view of Cornmarket showing the former 'new' Woolworths building. The 'old' Woolworths building on the opposite side of the road was taken over by Boots.

THE ADVENT OF LARGE-SCALE INDUSTRY

W e have seen that despite its period of steady growth during the nineteenth century, Oxford had very few major industries, the principal sources of employment being the university and various service industries such as transport, domestic service, printing, building and retail trades. This situation was utterly transformed during the twentieth century as a result of the enterprise and initiative of William Morris (1877–1963), who is arguably one of Oxford's greatest historical figures.

WILLIAM MORRIS

William Morris was born in Worcester, the eldest son of Frederick Morris of Witney and his wife, Emily Ann of Wood Farm, Headington. He attended Cowley village school until the age of fifteen, and having been apprenticed for a short time to an Oxford bicycle maker, he started his own bicycle repair business in his parents' house at No. 16 James Street, Oxford, at the age of just sixteen. The new venture prospered, and in 1901 Morris set himself up as a cycle manufacturer.

In 1902 he built the first Morris Garage on the site of a disused livery stables in Longwall Street, the new building (now Grade II listed) being designed by Messrs Tollit & Lee. In the following year he entered into a partnership with a wealthy undergraduate whose spendthrift ways brought bankruptcy to the Oxford Automobile and Cycle Agency, of which Morris was works manager. A small bank loan allowed him to start in business, and in 1912 he founded W. R. M. Motors Ltd, with himself as the sole ordinary shareholder. The new venture was financed with the aid of a £4,000 loan from the Earl of Macclesfield (in the form of preference shares). The earl was a motoring enthusiast, and Morris had known him since 1905 when, as an undergraduate, he had been involved in a collision while driving a car hired from Morris.

In 1912, Morris rented a former school at Cowley known as the Military College, which he adapted for use as a car factory, the very first Morris car – the two-seater Morris Oxford – being produced in 1913. An additional building known as the 'he Old Tin Shed' was built to the north of the school, while 'B-Block' and the main production lines were added in the 1920s and 1930s respectively. By 1939, the car plant employed over 2,000 people, and Morris Motors had overtaken Ford as Britain's largest car manufacturer.

Above left: William Morris, who became Viscount Nuffield in 1938.

Above right: The former Morris Garage at No. 21 Longwall Street. In later years Lord Nuffield had an office on the first floor of this building. The garage was threatened with demolition in 1977, but the frontage, side elevation, and roof structure were retained, and the buildings is now used as student accommodation for New College.

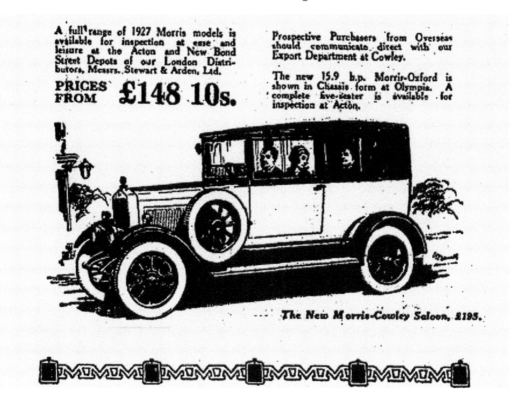

A full range of 1927 Morris models is available for inspection at ease and leisure at the Acton and New Bond Street Depots of our London Distributors, Messrs. Stewart & Arden, Ltd.

PRICES FROM £148 10s.

Prospective Purchasers from Overseas should communicate direct with our Export Department at Cowley.

The new 15.9 h.p. Morris-Oxford is shown in Chassis form at Olympia. A complete five-seater is available for inspection at Acton.

The New Morris-Cowley Saloon, £195.

A Morris advertisement from around 1927 depicting 'the new Morris Cowley saloon', which was reasonably priced at just £150.

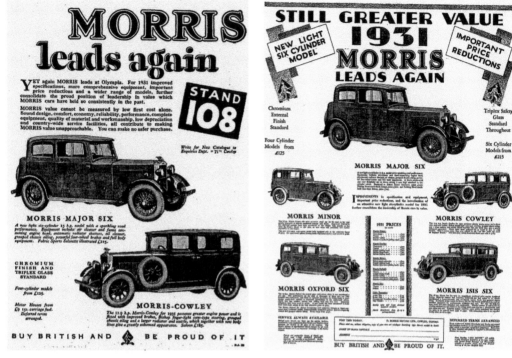

Above left: Morris advertising material from 1931 showing the Morris Cowley and the 'new, light six-cylinder Morris Major Six'. Morris cars developed a reputation for quality, reliability and ease of maintenance at reasonable cost, which was possible because of economies of scale.

Above right: A further example of Morris Motors advertising during the interwar period.

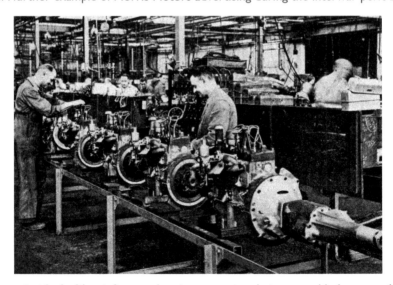

A glimpse inside the Morris factory showing car engines being assembled on a production line near the machine shops. Inspired by the example set by Henry Ford in America, Morris pioneered production line assembly in the United Kingdom.

These scenes from inside the Morris factory show completed engines undergoing exhaustive testing. Each engine was expected to generate a specific horsepower at a given number of revolutions, which was indicated by dials on the rear of the test bed. Skilled operators listened for irregular sounds with the aid of stethoscopes.

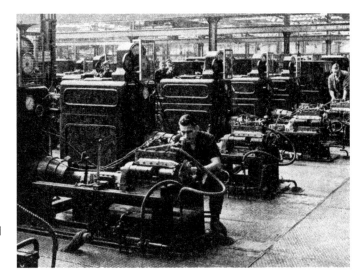

Meanwhile the car bodies were being formed in the press shop, in which huge presses were used to transform sheets of steel into sides, doors and other body parts, which would soon be assembled into complete body units.

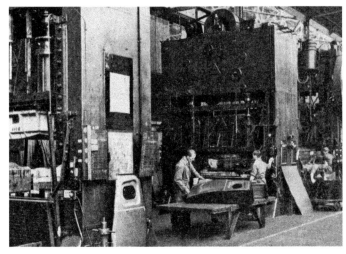

The car bodies were assembled in a huge jig, which held the various components in place while they were joined together. The following photographs show Morris cars under construction at Oxford during the 1930s and 1950s.

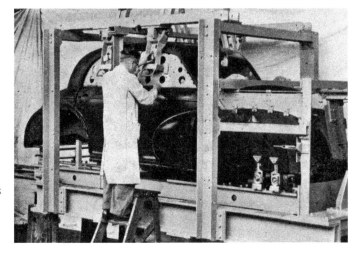

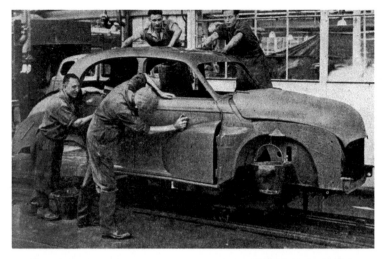

The car body was then dipped into an anti-rust solution and given several coats of priming paint – the body being rubbed down with emery paper between each coat, in order to ensure a smooth finish for the colour coats.

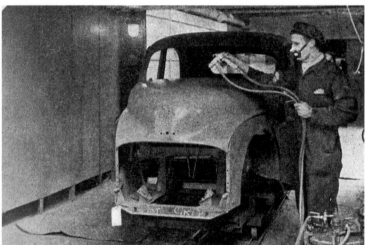

Having received its priming coats the body passed into spraying booths in which the colour coats were applied with spay guns. The photograph shows a worker in the booth wearing a respirator because of the fumes. Large ventilators in the roof extracted the worst of the fumes.

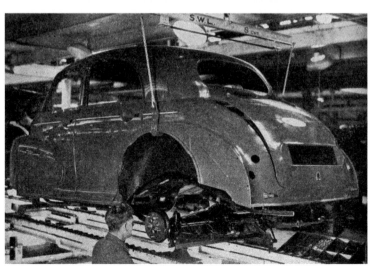

The newly painted car body is lowered onto a moving track upon which the rear axle is already in position. The assembly workers are stationed in pits beneath the track and, with the aid of special tools, the shackle pins attaching the springs to the body are put into position.

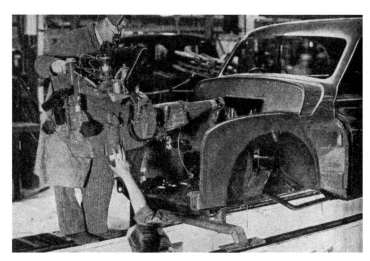

Progressing slowly along the track the car body moved under a platform from which a crane lowered the engine into its place at the front of the vehicle, which was also carried out over a pit.

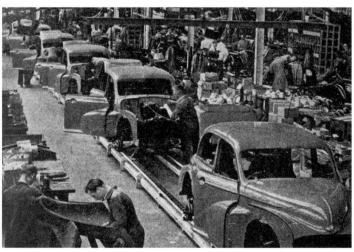

The front suspensions were assembled as the cars were carried steadily forward on the assembly lines. The cars shown in these illustrations are now taking recognisable shape as Morris vehicles.

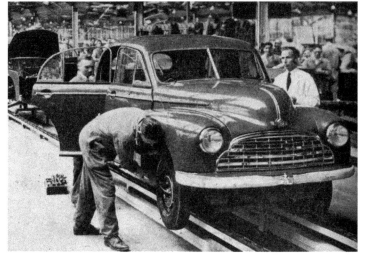

As the cars continued slowly along the production line they were fitted with seats, carpets and other interior fittings.

The wheels were fitted at the end of the production line, and having passed an inspection the finished cars were taken out for a road test, as shown in the final photographs in this section.

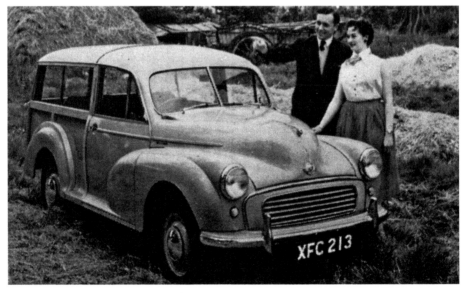

Another Morris publicity photograph showing a Morris Minor Traveller. The standard Morris range during the mid-1950s comprised a family of four vehicles: the Morris Minor, the Morris Oxford, the Morris Cowley and the Morris Isis. The Morris Minor saloon was one of the most popular small cars in the world. With a top speed of 65–70 mph, it was available as a two- or four-door version, while its petrol consumption was around 40 miles per gallon. The two-door saloon cost £560 17s in 1956.

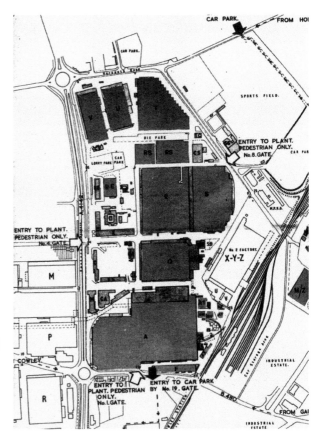

Right: A plan of the Pressed Steel site in 1976, by which time it had become the Cowley Body Plant.

Below: A present-day MINI car, which was built at the Cowley plant.

Two views of
the present-day
MINI plant in
June 2013.

In 1926 Morris opened the Pressed Steel body plant as a joint venture with the Budd Company of America and J. Henry Schroder, a merchant bank. Morris and the Budd Company subsequently withdrew, leaving Pressed Steel as an independent concern, and there were thus two factories at Cowley – although both eventually became part of the British Motor Corporation (later British Leyland). After many vicissitudes, the factories were acquired by BMW. The North and South Morris works were demolished, but the former Pressed Steel site was modernised and re-equipped so that it could produce an all-new version of the highly successful MINI. Over 20,000 people worked at Cowley in the 1970s, whereas today the workforce is around 3,700.

William Morris was created a baronet in 1929 and raised to the peerage as Baron Nuffield in 1934, while in 1938 he became Viscount Nuffield – taking his title from the name of the Oxfordshire village in which he lived. In addition to his role as a major industrialist, Morris was also a noted philanthropist, who donated no less than £30 million to charitable causes. In 1904 he married Elizabeth Maud Anstey (c.1884–1959), the daughter of William Jones Anstey, an Oxford farrier, but the couple were childless.

CONCLUSION

Having experienced a period of unprecedented growth during the early to mid-twentieth century the population of Oxford reached 80,540 by 1931 and 106,150 in 1961, while in 2011 Oxford had an estimated population of 151,900. The university is still the most important local employer, with a staff of over 13,000 (excluding those employed by the colleges or the Oxford University Press). Other major employers include local government and the National Health Service, while the presence of the MINI plant at Cowley ensures that manufacturing remains a significant local activity.

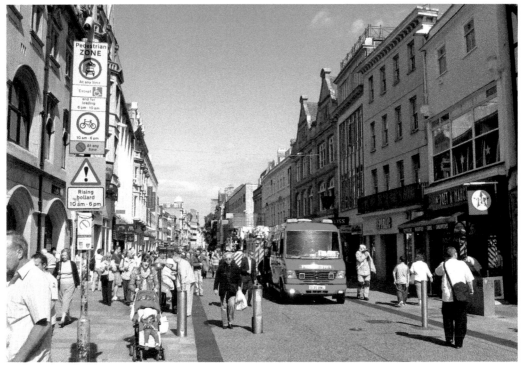

A busy scene in Cornmarket Street, which remains Oxford's principal shopping street.

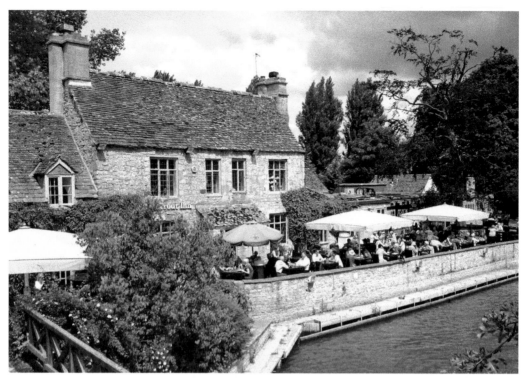

Oxford is a major tourist destination, as exemplified by this view of the Trout Inn at Wolvercote.

A final view of a Cowley-built MINI car, this being an example of a courtesy car owned by Mac's Garage of Witney.